VICTORIA AND ALBI

English Sculpture 1720–1830

by MARGARET WHINNEY

London: Her Majesty's Stationery Office
1971

© Crown copyright 1971

Museum Monograph No. 17

SBN 11 290083 6

CONTENTS

Foreword 5

Notes on sources and abbreviations 6

Introduction:
 I The Collection 7
 II Materials 8
 III Sculptors 9
 IV Busts 11
 V Statues and Groups 13
 VI Monuments 15
 VII Reliefs 20
VIII Summary and Conclusion 21

 1 David Le Marchand. Matthew Raper. Relief in ivory. 26
 2 David Le Marchand. Time, Opportunity and Penitence. Group in ivory. 28
 3 Laurent Delvaux. Vertumnus and Pomona. Group in marble. 32
 4 Michael Rysbrack. Canon Finch. Bust in terracotta. 36
 5 Michael Rysbrack. Sir Isaac Newton. Statuette in terracotta. 38
 6 Michael Rysbrack. Thomas Wentworth, 3rd Earl of Strafford. Statuette in terracotta. 40
 7 Michael Rysbrack. An Allegory of Charity. Relief in terracotta. 42
 8 Michael Rysbrack. Rubens. Statuette in bronze. 44
 9 Michael Rysbrack. Van Dyck. Statuette in bronze. 46
10 Michael Rysbrack. John Locke. Statuette in terracotta. 48
11 Michael Rysbrack. Flora. Statuette in terracotta. 50
12 Michael Rysbrack. King George II. Bust in marble. 52
13 Michael Rysbrack. Fame. Statuette in terracotta. 54
14 Peter Scheemakers. Dr Hugo Chamberlen. Statuette in terracotta. 58
15 Peter Scheemakers. Richard Temple, Viscount Cobham. Bust in marble. 60
16 Sir Henry Cheere. Lord Chief Justice Raymond. Bust in marble. 64
17 Giovanni Battista Guelfi. Anne, Duchess of Richmond. Bust in terracotta. 68
18 Thomas Adye. John Fane, Earl of Westmoreland. Bust in marble. 72
19 Thomas Adye (attrib.). Paul Joddrell. Bust in marble. 74
20 Louis-François Roubiliac. George Frederick Handel. Statue in marble. 78
21 Louis-François Roubiliac. Alexander Pope. Bust in marble. 80
22 Louis-François Roubiliac. Jonathan Tyers. Bust in terracotta. 82
23 Louis-François Roubiliac. Model for the Argyll monument. Terracotta. 84

24 Louis-François Roubiliac. Earl of Chesterfield. Bust in bronze. 86

25 Louis-François Roubiliac (attrib.). Dr Salmon. Bust in lead. 88

26 Louis-François Roubiliac (attrib.). Mary Salmon. Bust in lead. 90

27 Louis-François Roubiliac. Model for a monument to John, Duke of Montagu. Terracotta. 92

28 Anon. Duke of Cumberland. Bust in lead. 94

29 Joseph Wilton. Dr Cocchi. Bust in marble. 98

30 Joseph Wilton. Oliver Cromwell. Bust in marble. 100

31 Joseph Wilton. Oliver Cromwell. Bust in terracotta. 102

32 Nathaniel Smith. William Beckford. Statuette in terracotta. 106

33 Christopher Hewetson. Pope Clement XIV. Bust in marble. 110

34 Joseph Nollekens. Castor and Pollux. Group in marble. 114

35 Joseph Nollekens. Sir George Savile. Bust in marble. 116

36 Joseph Nollekens. Dying Hero. Sketch model in terracotta. 118

37 Joseph Nollekens. Mrs Howard of Corby. Sketch model in terracotta. 120

38 Joseph Nollekens. Charles James Fox. Bust in marble. 122

39 Joseph Nollekens. Laocöon. Sketch model in terracotta. 124

40 Thomas Banks. Thetis and her Nymphs. Relief in marble. 128

41 Thomas Banks. Thetis dipping Achilles in the River Styx. Group in marble. 130

42 Thomas Banks. Dr Anthony Addington. Bust in marble. 132

43 Thomas Banks. Achilles arming. Statuette in terracotta. 134

44 John Flaxman. Self-portrait. Relief in terracotta. 138

45 John Flaxman. The Ancient Drama. Two reliefs in plaster. 140

46 John Flaxman. The Modern Drama. Two reliefs in plaster. 142

47 John Flaxman. St Michael overcoming Satan. Group in plaster. 144

48 Sir Francis Chantrey. John Raphael Smith. Bust in marble. 148

49 Sir Francis Chantrey. William Stuart, Archbishop of Armagh. Bust in marble. 150

50 Sir Francis Chantrey. Bishop Heber. Sketch model in clay. 152

51 Alexander Goblet. Joseph Nollekens. Bust in marble. 156

52 Samuel Joseph. King George IV. Bust in marble. 160

FOREWORD

The Victoria and Albert Museum is deeply indebted to
Dr Margaret Whinney for generously undertaking to write the
first official publication on English sculpture of the eighteenth
century. Although, as is shown in the text, this part of the
collections has been radically transformed by the acquisitions of
recent years, the time for issuing a comprehensive catalogue has
not yet arrived. Dr Whinney's book provides a detailed
description of over fifty works of art and a general introduction
to the subject. The individual descriptions are based on the
records of the Department of Architecture and Sculpture; and
Dr Whinney wishes to acknowledge the help given by members
of that department and particularly by Mr Terence Hodgkinson,
the Keeper.

John Pope-Hennessy
Director

The standard work on English sculptors is R. Gunnis, *Dictionary of British Sculptors, 1660–1851*, 1953; 2nd edition, with slight amendments, 1969. To save repetition, this book has not been quoted at the end of each biographical note, but such notes could not have been compiled without it.

References are given to a recent general survey, M. D. Whinney, *Sculpture in Britain, 1530–1830* (Pelican History of Art), 1964, only when specific passages enlarge the arguments put forward here.

The following abbreviations have been used:

Burl. Mag. *Burlington Magazine.*

Vertue, II, III, IV *The Notebooks of George Vertue*, vol. II, *Walpole Society*, vol. XX, 1932–33; vol. III, *ibid.*, vol. XXII, 1933–34; vol. IV, *ibid.*, vol. XXIV, 1935–36.

Physick J. Physick, *Designs for English Sculpture 1680–1860*, Victoria and Albert Museum, 1969.

INTRODUCTION

I The Collection

The collection of English sculpture of the eighteenth and early nineteenth centuries in the Victoria and Albert Museum is both high in quality and wide in range. This claim could not, however, have been made forty years ago. For of the fifty-two works of art discussed in this book, only eleven were in the Museum's possession in 1930. Twelve were added before 1945, but twenty-nine more have been acquired since that date. These facts suggest a considerable change of taste. In the early years of this century post-reformation sculpture, with the possible exception of Elizabethan tombs, was much despised. The Victorian revival of interest in English medieval sculpture was still potent, and eighteenth-century work, with its use of classical types, and still more of classical allegory, was regarded as empty and bombastic. That the world of Antiquity had been a major force in the development of style after the end of the Middle Ages was thought to be unfortunate—if it was thought of at all; and its authority was so alien to modern life that its vital meaning to men of the eighteenth century was ignored.

The change of attitude, which began in the 1930s and which is now almost complete, was in the first place largely due to the enthusiasm of two scholars, Mrs K. A. Esdaile and Mr Rupert Gunnis. They laboured ceaselessly on what was practically virgin soil, travelling round England in order to find and record works which few other people troubled to look at, except with distaste. Their achievement did much to fire those in charge of the Museum's collection with the desire to extend its range. This was rendered more acceptable owing to the recognition, in the same decade, that baroque art was not only respectable, but often beautiful. Before that time it had been totally despised, partly because it was regarded as popish, but also because it was thought to be affected. The new estimate of baroque was strengthened by the work of German and Austrian scholars, refugees from Hitler's dictatorship, for they did much to help in the re-assessment of English work. Moreover, as the disciplines of art history became more firmly established in England, the position of English sculptors in European art could be analysed with a new and surer sense of values. The high quality of the pieces acquired

since 1945 is clear enough testimony that the change of attitude is complete, and that works once considered distasteful, or at best boring, are now regarded as worthy of a place in a national museum.

II Materials

The material most constantly used by sculptors of the period was marble, imported from Italy. Its beauty of surface and its durability have always made it the favourite medium. The work in marble, several examples of which are illustrated here, was, however, the final stage, and some preliminary work in other mediums was necessary.

The first stage might well be a drawing. This was usually produced for the approval of the patron, especially if the work was a monument. A number of such drawings in the Victoria and Albert Museum, sometimes showing preliminary stages of a design, are illustrated in a recent Museum publication, *Designs for English Sculpture 1680–1860*, by John Physick, 1969.

When the design had been agreed between sculptor and patron, models, sometimes more than one for a single work, were usually made in clay. But clay, if left to dry, has a tendency to shrink and crumble, and so would be unsatisfactory as a pattern. The model was therefore fired in a kiln, and became terracotta. The process was not easy, for accidents could easily occur in firing, but it gave permanence to the clay. Models might be made full-size, as was usual in bust sculpture, or they could be small sketch-models of single figures which were to form part of a large monument. Some sculptors tended also to make small rough sketches in clay of the first design of a large work. Terracottas of all these classes are in the Museum's collection. Such works are of great importance in the study of sculpture, for they are always the work of the master himself, and are often far more sensitive and lively than the final marble, which in many cases was worked on by assistants. Even when the latter does not occur there is usually a freshness in the model which is lost in the marble. The Museum is lucky in possessing one work (Nos. 30 and 31) with an example in both mediums, and fine though the marble is, it is easy to see the superiority of the terracotta.

In the last quarter of the eighteenth century a change occurred in studio practice. Instead of risking the complications of sending

the model to be fired—for few sculptors had their own kilns—
a cheaper and safer process was adopted. The clay model was
lightly greased, and then covered with a skin of plaster to make
a mould. When the mould had hardened, the clay was picked
out, leaving a clean mould from which a plaster cast could be
made. Such casts are the equivalent of the terracotta model, and
show the master's modelling of the clay original. At the same
time, improvements were made in the pointing machine, whereby
the dimensions of the original could be transferred to the marble;
and this meant that more of the work on the marble could be
done by assistants. In most but not in all cases the master gave
a final working to the marble, but the somewhat dead quality
of many large early nineteenth-century works (not represented
in the Museum) suggests that even the finishing was left to
assistants.

Two early eighteenth-century works in ivory are also included
in this book, for they were certainly made in England. The
material continued to be used, notably for miniature portraits,
until much later in the century, but it tended to become a
separate craft, and did not attract the major sculptors.

Bronze, the most permanent of the sculptor's materials, was
used sparingly in England throughout the eighteenth century,
and chiefly for works to be placed out of doors, above all for
equestrian statues. Lead, which is less attractive and cheaper, was
much used for garden figures, but also occasionally for busts or
small statues.

III Sculptors

The chief fields in which English eighteenth-century sculptors
worked were statues and busts, both of the living and the dead,
busts being far more numerous than whole figures; funerary
monuments, which may indicate a burial or may be purely
commemorative; reliefs, often but not always for chimney-pieces;
and garden ornaments. With the exception of the last class, which
is barely represented in the Museum, a fair picture of the
development of style in each category can be gained from the
examples illustrated here.

Before these groups are analysed, however, some brief discussion
of the sculptors must be included, though a short biography of
every artist will be found at the beginning of the section on

his work. It will quickly be apparent that the leading sculptors in the first half of the eighteenth century were foreigners by birth, though several of them spent their whole working lives in England, building up large and very successful practices. The reason is not far to seek. English sculpture in about 1700 was extremely provincial in character, chiefly because opportunities for training, beyond that of the mason's yard, scarcely existed. It is true that a few sculptors started life as assistants to older artists, but the standard of work was low, and they seldom exceeded their master. In 1694 Sir Christopher Wren perceived that the basic weakness in England was the lack of instruction in drawing, 'to which everybody in Italy and France and the Low Countries pretends to more or less'. England therefore presented good opportunities to well-trained foreign sculptors. Moreover, the development of the Grand Tour after the end of the long wars with France in 1715 opened the eyes of many English gentlemen to the desirability of good sculpture, and the demand for it increased. A number of the foreigners came from Antwerp, where patronage had declined after the wars, but where the standard, both of training and of execution, had been very high in the seventeenth century. On the other hand, David Le Marchand and Louis-François Roubiliac were French, the latter being almost certainly a Huguenot.

The studios of these highly competent immigrant sculptors were potential training grounds for Englishmen. But the eighteenth century also saw the development of the art school in England, culminating in the foundation of the Royal Academy in 1768, with the Royal Academy Schools as an integral part of the scheme. This gave new opportunities both in training and in the granting of travel scholarships; but even before the foundation of the Academy English sculptors, such as Joseph Wilton or Joseph Nollekens, had proved the value of a journey to Italy. Moreover, throughout the century, the increasing number of books with engravings of classical art gave to patrons, whether they had themselves travelled or not, a standard whereby they could judge works they had commissioned. A similar standard was provided by the collections of antiques, real or faked, which were built up in many great houses at that time. It would, however, be totally wrong to suppose that English eighteenth-century sculpture is merely an imitation of the Antique. The taste for the Antique was certainly stronger, up to about 1770, than in any other country of Europe, but sculptors such as Rysbrack and Roubiliac, trained in the late baroque tradition, made their own, often brilliant,

10

adjustments of style, and produced a personal and lively art which does not always fall easily into the categories of the art historian.

At the end of the eighteenth and the beginning of the nineteenth century neoclassicism was an international movement, and English sculptors are part of it. But even there they do not always entirely conform, for their works show a tension, or more often an overriding sentiment which is nearer to romanticism than to the classical world.

IV Busts

The bust, within the period under consideration, is better represented in the Museum than any other form of sculpture, and this reflects, fairly enough, its enormous popularity after about 1720. Busts, both as objects to adorn a house, or as part of a monument, had been made in the seventeenth century, but they were relatively rare. In the second quarter of the eighteenth century the English passion for portraiture found new expression in the sculptured bust, while portrait painting (Hogarth apart) was at a fairly low ebb. Busts which are direct imitations of classical types first appear in about 1723, and the fashion was to persist throughout the period. The earliest bust of this kind in the Museum's collection is Peter Scheemaker's *Viscount Cobham* of c. 1740 (No. 15), in which the pattern, with the drapery brooched on one shoulder and hanging in loops across the chest, is a straight derivative from Roman busts. Thomas Adye used a similar pattern in No. 19, while in his bust of the *Earl of Westmoreland* of 1742 (No. 18) he employs the alternative of Roman armour.

The bust of *Lord Chief Justice Raymond* of 1732 (No. 16), almost certainly by Henry Cheere, is a variant of the antique bust in which the drapery is more freely disposed, but the face is less interesting than the drapery, and this portrait may well be a posthumous one.

Most leading sculptors made busts in the antique manner, though variations which are not strictly antique were often introduced. At the same time, they also made portraits in contemporary dress. The earliest of the fine groups of works by John Michael Rysbrack in the Museum (No. 4) falls into this category, though this sculptor appears to have been responsible for the first of the long line of classicizing busts. His bust of

Canon Edward Finch shows the sitter in his robes as a Doctor of Divinity, and wearing the soft nightcap which men put on when they removed their wigs. The broad, forceful modelling of the face is typical of the sculptor, and is here used in deliberate contrast to the small soft folds of the surplice. The only other bust by Rysbrack (No. 12) is neither strictly classical nor strictly contemporary, though it has some trace of both types. *George II* is laurel-crowned, like a Roman hero, wears his wig and the orders of the Garter and the Bath, but also wears richly chased armour, which is surely ideal rather than contemporary. Another fairly early bust in contemporary dress is Giovanni Battista Guelfi's *Duchess of Richmond* (No. 17). It was probably made from a painted portrait, and, though a terracotta, it is strangely insensitive in modelling.

The busts of Louis-François Roubiliac are among the finest ever made in England. He had an exceptional gift for conveying character in the whole design of a bust, whether classical or contemporary, and his interest in small rather than bold forms, characteristic of all rococo sculptors, enables him to give individuality to the features. His bust of *Alexander Pope* (No. 21) is among his most penetrating portraits, and is also an admirable example of his free approach to the arrangement of classical drapery. His *Chesterfield* (No. 24), superb in characterization, is an early example of the undraped bust which was to be more widely used after the middle of the century. The *Jonathan Tyers* (No. 22) on the other hand shows his patron, who was undoubtedly a good man of business, in contemporary dress, while the *Dr and Mrs Salmon* (Nos. 25 and 26), attributed to him because of their high quality, are further examples of the informal bust.

The Museum is fortunate in possessing admirable examples of the busts of Joseph Wilton. The *Dr Cocchi* (No. 29) is probably his best portrait in the antique manner, and is completely without drapery. The *Oliver Cromwell* (Nos. 30 and 31) is a distinguished illustration of the vogue for busts of men long dead. Such busts of poets, scholars and statesmen were in demand as suitable decorations for a gentleman's library. Many are still in their original positions in great houses, or in colleges, while others have found their way into museums.

In the last quarter of the eighteenth century the classicizing bust is far more frequent than the bust in contemporary dress. The design of such busts is, however, far freer than it had been in the age of Scheemakers. Drapery is now thrown loosely about the

shoulders, and is no longer brooched as in antique busts. Joseph Nollekens (Nos. 35 and 38) was exceptionally skilful in the variety of his patterns, often adding point to his shrewd characterization of the head by the disposition of the drapery below it. The *Addington* of Thomas Banks (No. 42) is, on the other hand, less inventive and more firmly based on Antiquity than the busts of Nollekens, though it is a most compelling portrait.

Christopher Hewetson, though working in Rome, appears to stand a little apart from his contemporaries in his *Clement XIV* (No. 33) in papal robes, though he also made distinguished classical busts, while Flaxman's naturalistic *Self-Portrait* (No. 44) was modelled so early in his career that it cannot be regarded as typical of his style.

The group of early nineteenth-century busts shows the final assimilation of the classical pattern. Goblet, a competent sculptor of little originality, keeps to the undraped style in his portrait of his master *Nollekens* (No. 51). Samuel Joseph uses Antiquity almost as a form of fancy-dress for his idealizing portrait of *George IV* (No. 52). Sir Francis Chantrey, however, one of the greatest portrait sculptors ever to work in England, simplifies and broadens his drapery patterns in the bust of the *Bishop of Armagh* (No. 49), so that they combine the timelessness of antique dress with some indication of the profession of the sitter. And in the *John Raphael Smith* (No. 48) the convention of the bare chest with a cloak over the shoulders is combined unselfconsciously with the tasselled cap, and the firm delineation of the features helps to render this one of the most striking busts in the Museum.

V Statues and Groups

The sequence of statues, represented in some cases by statuettes, is less complete than that of busts; but much can be deduced from it about changes of style. Among the statues, moreover, is Roubiliac's *Handel* (No. 20), perhaps the most important work in the collection of English sculpture.

The earliest is the group of *Vertumnus and Pomona* (No. 3), made about 1725 by the able Fleming, Laurent Delvaux. It is a relatively youthful work, and the broad fleshy forms and the flowing draperies clearly reveal the sculptor's origin in the late baroque school of Antwerp. It is not unrewarding to compare the design with that of David Le Marchand's *Time, Opportunity and*

Penitence (No. 2). The scale is naturally entirely different, the ivory being only eight inches high and the Delvaux group more than four feet. But the ivory is an adaptation of a full-size sculpture of 1678 by Regnaudin at Versailles, in which the design is far more controlled and the twisting forms wind upwards in a taut, spiral movement.

John Michael Rysbrack's sketch for the statue of *Thomas Wentworth, 3rd Earl of Strafford* (No. 6) is characteristic, in its use of classical armour combined with broad and deeply modelled drapery, of much of the sculptor's work. The modelling is vigorous, but the stance of the figure, which was changed in the final marble, is a little uneasy. The sculptor's skill is shown to greater advantage in the statuettes of *Rubens* and *Van Dyck* (Nos. 8 and 9). In both the pose is beautifully balanced, they have an elegance which is entirely absent in the *Strafford* and which, with the small broken surfaces of light and shadow, relate them to rococo rather than to baroque art. The model for the statue of *John Locke* (No. 10) has also a tinge of rococo in the elegant proportions of the figure, with its small head, but the design, with its counter-balancing diagonals, has a strength which sets it apart from rococo art. It is, moreover, an excellent example of the use of classical dress in a totally unclassical manner. Rysbrack's remaining statuette in the Museum, the model for the *Flora* (No. 11), is yet another example of his adaptation of a classical idea. The figure is closely based on the Farnese *Flora* (now at Naples), but the proportions and the drapery lines are slightly changed, so that it has a lightness which brings it nearer the rococo taste of 1759.

Roubiliac is represented by one statue only, the seated figure of *Handel* (No. 20) of 1738. Though it is early, it is one of his greatest works, and it is, moreover, a landmark in European sculpture. It is an almost perfect example of rococo art, intimate, amusing and very lively in its modelling. It blends the reality of the portrait of a famous London character with the allegory of the lyre, and consequently of Apollo, the patron of music and the arts. Its excellent state of preservation makes it possible to see the brilliance of Roubiliac's handling, and above all his acute perception of small forms which at once give character and bring rapid variations of light and shade over the surface.

The two groups by Nollekens (Nos. 34 and 39) do not differ in size alone. The *Castor and Pollux* (No. 34), made in 1767 during the sculptor's stay in Rome, is a close copy of the Antique, and shows that his work as a restorer of mutilated statues had led him to assimilate completely a somewhat dry form of the antique

manner. The *Laocöon* (No. 39) dates from much later in his life, and was modelled for his own pleasure. It is a free variation of the famous group, and reveals that Nollekens was not, at heart, a neoclassical sculptor. Indeed, the spiral composition of the little group suggests that he had looked with admiration at the baroque and also makes the strongest possible contrast with the purely frontal design of the *Castor and Pollux*.

Thomas Banks's *Thetis dipping Achilles in the River Styx* (No. 41) must, on the other hand, be regarded as a neoclassical work. The simplified forms, the clean contours, and indeed the whole design, which should be judged from the side and not the front, betray the sculptor's knowledge of the new assessment of Antiquity.

John Flaxman's *St Michael overcoming Satan* (No. 47), was considered by his contemporaries to be his best statue. Viewed from the front, with the straight vertical of the spear binding the two figures together, it is an impressive composition, though the side view is a little ragged. It shows how, nearly at the end of his life, Flaxman was willing to attempt a combination of Antiquity and Christianity. The theme is Christian, but the saint is closer to a Perseus than to the traditional iconography of an archangel. The breadth of Flaxman's interests can be gauged from his Italian sketch-books in the Museum; though they are some thirty years earlier than this group it seems certain that recollections of Cellini and perhaps even of Michelangelo were still in his mind, but were now fused with other influences, and expressed with a lyrical spirit which was his own.

VI Monuments

Some important small figures have been deliberately excluded from the last section, for they are sketches made in preparation for monuments. The tomb or monument has always been one of the chief fields for sculpture in England, and some of the finest work of English sculptors is to be found in village churches. Much, however, is in Westminster Abbey and, after 1795, in St Paul's Cathedral, though unfortunately many fine monuments in the Abbey are hard to see. The Museum is lucky in possessing models of three of the most distinguished, from which much can be learnt not only about the style of the sculptors, but also about the development of monumental design.

The two which must be considered first are very nearly

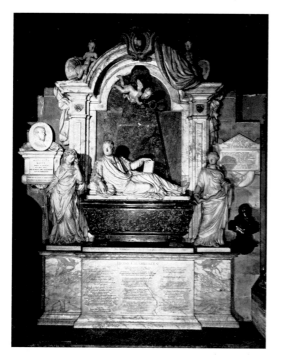

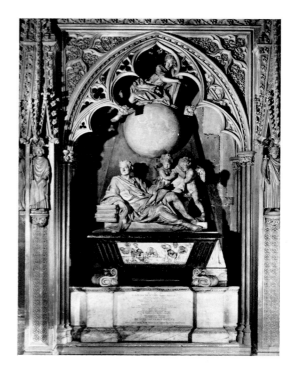

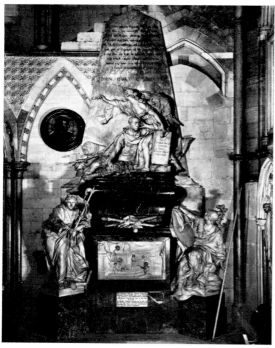

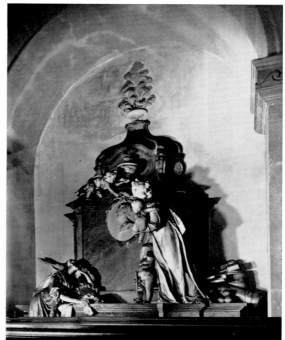

Fig. 1. Monument in Westminster Abbey by P. Scheemakers and L. Delvaux to Dr Hugo Chamberlen

Fig. 2. Monument in Westminster Abbey by J. M. Rysbrack to Sir Isaac Newton, designed by William Kent

Fig. 3. Monument in Westminster Abbey by L.-F. Roubiliac to the second Duke of Argyll and Greenwich

Fig. 4. Monument in Warkton church, Northamptonshire, by L.-F. Roubiliac to the second Duke of Montagu

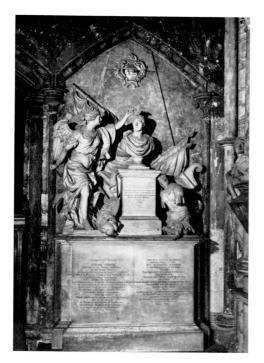

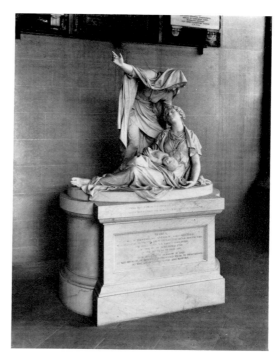

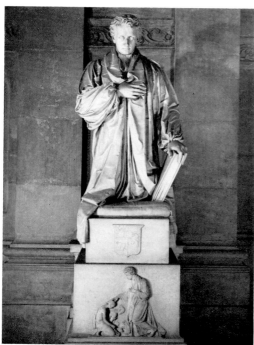

Fig. 5. Monument in Westminster Abbey by J. M. Rysbrack to Admiral Vernon
Fig. 6. Monument in Wetheral church, Cumberland, by J. Nollekens to Mrs Howard of Corby
Fig. 7. Monument in St Paul's Cathedral, London, by Sir Francis Chantrey to Bishop Heber

contemporary. The effigy of *Dr Hugo Chamberlen* by Peter Scheemakers (No. 14) is for a Westminster monument erected in 1731 (Fig. 1), while Michael Rysbrack's monument to *Sir Isaac Newton* (Fig. 2), for which No. 5 is a model, was finished in the same year. There is, however, some reason to believe that the Scheemakers was begun before 1728, so it is discussed first. The type of monument, with the effigy reclining in contemporary dress and an allegorical figure standing at each side, was not new; but while most earlier examples had a massive architectural canopy, here the main emphasis is on the sculpture. The effigy is an unusually lively work for Scheemakers—indeed, if he could be judged by this model and the bust of *Cobham* (No. 15) alone, he could be rated more highly than is possible when his large output, much of it mediocre, is considered. The two allegorical figures, the Goddesses of Health and of Longevity, strongly suggest the influence of Antiquity. One of them is by Laurent Delvaux (q.v.), who worked with Scheemakers in the 1720s, and it seems probable that the one on the left, which is the more baroque of the two, is his, while the Goddess of Health has the straight-falling drapery of Roman sculpture.

Rysbrack's *Sir Isaac Newton* (No. 5 and Fig. 2) is one of the finest monuments in the Abbey, though the impression it makes is marred by the nineteenth-century screen, which hides part of the upper figure. Unlike Chamberlen, Newton wears the timeless robes of Antiquity, and the whole design, which has no architectural features, the figures being set against the pyramid of Eternity, is more novel. Moreover, though both Newton and the figure of Astronomy seated on the Globe wear classical garments, these are treated with great freedom. Rysbrack gives vitality to his figures by combining large folds, making deep shadows, with small folds, which make a roughened surface. In this, and in the building of his whole design on diagonals, Rysbrack shows himself a more baroque artist than Scheemakers, who always prefers to use small folds in repeating curves.

Louis-François Roubiliac's first major London monument, the *Duke of Argyll* (No. 23 and Fig. 3) of 1745–49, is an even more daring conception, for it has drama, chiefly through the use of figures in movement, which is absent in the earlier monuments. Further, it is far more asymmetrical in design than Rysbrack's *Newton*, in which the diagonals of the main groups are, as it were, caught and held down by the figure of Astronomy above in the centre. In the *Argyll*, the main group, which shows the Duke dying in the lap of Fame, who writes his name on the pyramid

of Eternity, is planned on two unequal diagonals, linked only loosely with the Pallas and Eloquence below. No sculptor had before this attempted anything so dramatic as the figure of Eloquence leaning forward with her arm outstretched to her invisible audience. As might be expected, the drapery patterns are extremely complex, and are used to give that movement of light over the surface which, with the asymmetry of the design, proclaims this to be one of the major examples of rococo sculpture in England.

All these rococo characteristics are even more marked in Roubiliac's other model in the collection, that for the *2nd Duke of Montagu* (No. 27 and Fig. 4) at Warkton, Northamptonshire. It is more than ten years later than the Argyll, and has a sentiment which is absent from the London work. Again a figure is shown in action, but, since she is Charity, her movement is less urgent than that of Fame; the asymmetry is now even stronger, and the variety in the handling of drapery more masterly.

The *Fame* of 1760 (No. 13), a model by Rysbrack for his monument to Admiral Vernon (Fig. 5) at Westminster, is later than the two Roubiliacs, and is clearly influenced by them. It is unusual for Rysbrack to attempt a figure in motion, and the whole monument is more asymmetrical than his earlier work. The terracotta is an impressive production for an old sculptor attempting a new style, but the figure becomes more ponderous in the marble.

Both Roubiliac's monuments have a three-dimensional quality in their design. The figures are on different planes, and the movement runs up and back, in the Montagu running almost in a spiral. And the garments are not strictly classical. A marked change was to appear in the work of the next generation. Joseph Nollekens's *Mrs Howard of Corby* (No. 37 and Fig. 6) at Wetheral, Cumberland, is about fifty years later than Roubiliac's *Montagu*, and the increased veneration for Antiquity is easy to see in the final design. The head and limbs of Mrs Howard and of the figure of Religion are generalized, and rendered in smooth, rounded forms, the dress is much more strictly classical, and the movement is across and not into the group, the arm of Religion being carefully placed so that it is parallel to the main plane.

That Nollekens did not always begin his planning on neoclassical lines can be seen from the first model for *Mrs Howard* (No. 37) and also from the abortive sketch (No. 36) of a Hero dying in the arms of Victory. Had the latter been carried through to the marble, the spiral movement would no doubt have been disciplined.

The *Mrs Howard* is the only sketch model for a neoclassical monument that is illustrated; unfortunately there are no models of this kind by Banks or Flaxman in the collection. But the swing back to a naturalism which is, to some extent, linked with the romantic movement is exemplified by Sir Francis Chantrey's sketch (No. 50 and Fig. 7) for the monument to *Bishop Heber*. All allegory, whether Christian or pagan, has now disappeared. The bishop, a free-standing figure with no background, is shown kneeling as in life, wearing his episcopal robes. The handling is broad and firm, the conception direct and simple. The world of the eighteenth century, with its nostalgia for Antiquity, has gone, and the bishop belongs to a new age, eager to meet the challenge of the present.

VII Reliefs

The reliefs in the Museum's collection are, in three cases at least, extremely revealing. David Le Marchand's *Matthew Raper* (No. 1) is, admittedly, an unusual work, but the attempt at illusionism, the heavy curling folds of the cloak, and the draped curtain in the background link it directly with the baroque.

Rysbrack's model for the *Allegory of Charity* (No. 7) is a far more important piece. Made in 1746 for a chimney-piece at the Foundling Hospital, it comes from the decade when rococo influences were at their height in England. The setting is pastoral, as in many rococo paintings, the scene has charm rather than grandeur, and the relief is varied between high and low, in such a way that the surface is broken by little flecks of light and shade. Its handling is therefore very close to Rysbrack's figures of *Rubens* and *Van Dyck* (Nos. 8 and 9), and far lighter than the firmly modelled head and deeply cut folds of the model of *Newton* (No. 5).

Thomas Banks's *Thetis and her Nymphs rising from the Sea to console Achilles for the loss of Patroclus* (No. 40) makes a most telling contrast to Rysbrack's *Charity*. The mood is not pastoral but heroic—Flaxman described the work as 'of the epic class'—and with the change of mood there is a complete change of handling. Banks was working in Rome when the relief was made in 1778, some thirty years later than the *Charity*, and the new ideals of neoclassicism were in the air. One important tenet of the new movement was the importance of contours. Banks's figures,

therefore, even when the relief is low, rise sharply from the ground. There is no blurring of the edges, and except for the indication of waves in the lower part of the relief, none of the pictorial quality which gives the *Charity* much of its charm. The modelling is smooth and rather hard, and there is an obvious recognition of the importance of the nude. Many of these characteristics are taken from antique art, but the building of the design on linear rhythms, and the exaggerated gestures of the figures do not come from Antiquity. The first is due to the talent of Banks, and the second, in all probability, to his friendship with Fuseli.

The reliefs after Flaxman for the Covent Garden frieze (Nos. 45 and 46) are also examples of neoclassical art, but though the subjects are dramatic, they have none of the tense agony of Banks. Except for the mounds on which certain characters are seated, there is no indication of a setting, and the figures are silhouetted against a plain ground. The subjects need reading before they can be understood, for to Flaxman content as well as handling was of importance, and their learned quality is very far indeed from the easy intention of the *Allegory of Charity*, which is obvious at the first glance. The contours are again sharp, though less so than in the Banks, and while Flaxman's talent for linear design is evident in every figure, this is slightly less apparent in the design of the whole. But above all it is clear that Flaxman's inspiration comes from a different source from that of Banks. Two years before he designed these works, he had reported on the condition of the Elgin Marbles, shown for the first time in London, and to his eternal credit had advised against restoration. At many points— the chariots and horses and the slow procession of Muses—the Parthenon frieze would seem to have been in his mind. If so, this is the earliest example of its impact on English sculpture.

VIII Summary and Conclusion

It will have become clear that English sculpture after about 1720 presents a late baroque style, though often much modified by classical influence. From about 1740 to 1770 a more rococo manner is dominant, though the older style still persists beside it. In the 1770s the first examples of neoclassical sculpture appear, though again older styles continue. Neoclassicism remains the correct style until well into the nineteenth century, but from

about 1810 it is combined with a surprising naturalism, especially in the work of Sir Francis Chantrey.

The sequence is, broadly speaking, that of Continental sculpture, though the strong classical trend early in the century is peculiarly English. It is right that sculpture in England should be seen as part of European movements, and assessed by European standards. But immediately this is attempted, certain limitations appear. There can be no doubt that English sculptors suffered from the narrow range of English patronage. No religious sculpture was required, so the valuable experience of sculptors working together on large schemes of church decoration was entirely lacking. There was no court patronage, and public patronage required little beyond an occasional statue or the small amount of architectural sculpture needed for the decoration of Somerset House. Patronage was therefore almost entirely private, and so inevitably limited in cost as well as in range. The most elaborate undertakings, throughout the period, were monuments; the most consistently high in standard were busts. The latter were part of the furnishing of the house. The Palladian style of architecture made no demands on the sculptor in exterior design, and, though the landscape garden was willing to tolerate occasional single figures, these were never allowed to become important features, such as the great fountains of many Continental baroque gardens, and many of the figures made were direct imitations of the Antique.

There was, therefore, far less opportunity for sculptors in England to learn through rivalry with other men, nor were there, until after the middle of the century, opportunities for young men to obtain recognition through the winning of a prize, as they could in France. And, as has been indicated, it was only after the foundation of the Royal Academy in 1768 that any organized training existed.

It is not surprising that good sculptors were relatively few, nor is it altogether easy to judge them fairly against their foreign contemporaries, especially those of Italy and France, where both the opportunities and the training were far more favourable. Rysbrack at his best, either in his most robust baroque works, or in the most distinguished pieces of his rococo phase, can hold his own against the sculptors of his native Flanders, and his finest busts have a force and an individuality which make them worthy rivals to those produced in France. He is an uneven sculptor, but his work suggests that, given a wider range of opportunities, he would have learnt by experience, and would have gained, for instance, a greater control over the standing figure. Scheemakers,

on the other hand, becomes weaker with experience, and his strong leanings towards Antiquity too often result in work which is respectable but dull. Compared with, for instance, Bouchardon or Donner, sculptors who made a close study of the Antique, Scheemakers appears as only a minor artist.

Roubiliac is even harder to assess. His finest busts are the equal of any produced in Europe in the eighteenth century, with the exception of those of Houdon. And his sense of design in his monuments, with its exploration of the possibilities of asymmetry, is often brilliant. Close parallels to it can be found in France, notably in the work of Michelange Slodtz, but there is no reason to believe that they knew each other's work, and both must be regarded as part of the general tendency of rococo art. Roubiliac's treatment of form, so sensitive when the object is near the eye, is, however, often too small in larger works, as indeed he himself realized after he had seen the work of Bernini. All the same, among sculptors working in England in the eighteenth century he stands out, both in quality and in originality. Sir Henry Cheere, who is not well represented in the Collection, is the other chief exponent of the rococo. Though he did not have the advantage of a foreign training, his best work shows that he had considerable ability.

The men of the next generation are hard to place in any category. Joseph Wilton hovers between a classical and a late baroque style, and his tendency to the latter would make him seem old-fashioned beside his Continental contemporaries. Joseph Nollekens produced many superb busts which show a very free use of classical patterns, but his work as a whole suggests that, though he was aware of the new ideals of the neoclassical movement, he was not seriously concerned with them. Indeed, his sketch-models (Nos. 36 and 39) and his drawings suggest that at heart he was a baroque artist.

Thomas Banks, however, fits firmly into the Continental pattern, and is indeed one of the first sculptors whose work is rigorously neoclassical from the start. But, as so often happened with northern neoclassicists, he constantly strives for a quality of expression (Nos. 40 and 43) which brings his art close to early romanticism. The same may be said of Flaxman, though he is a far more important artist, and in many ways a central figure in the neoclassical movement. He was probably the only English artist of the eighteenth century whose work was influential on the Continent, though the influence rested on his book-illustration rather than on his sculpture. Inevitably he must be set against his

great contemporary, Canova. It quickly becomes clear that he lacked the Italian's innate sense of form, and that his capacity for designing large works, whether groups or monuments, was infinitely less. On the other hand, Flaxman's great gifts for linear design show to advantage in his many small reliefs; for the smaller monuments of Canova, though beautifully modelled, are somewhat stereotyped and lacking in imagination. Flaxman could achieve a lyrical quality which can be very moving, even when tinged with didacticism. It was hailed by his contemporaries as 'poetic', and it is this which carries him over the threshold of the romantic movement.

The work of Sir Francis Chantrey, like that of other English sculptors, seems to embrace more than one ideal. He grew up in an atmosphere of neoclassicism and on occasions produced purely neoclassical works. But his own strong sense of naturalism, and his love of broad and simple forms, carried his art away from a close dependence on the Antique world. His subjects are rarely romantic, and he disliked all forms of enthusiasm. He cannot therefore be judged against his French romantic contemporaries, and the humanity and robustness of his art render a comparison with Thorwaldsen impossible. As so often happens with English art, he is a great artist going his own way, and producing works which have both originality and grandeur.

David LE MARCHAND 1674–1726

Little is known about this skilful ivory carver beyond a few
entries in the Note Books of George Vertue. These reveal that he
was born in Dieppe, had been 'many years' in England by 1723,
and that he died here in 1726. A few of his works are recorded by
Vertue, and other signed pieces are known, amounting to about
twenty-five busts, in relief or in the round, and a few allegorical
figures. The style of these works suggests that Le Marchand was
trained in France in the baroque tradition, but that he was, on
occasions, prepared to bring considerable originality to his work,
as in No. 1.

Vertue, vol. II, pp. 47, 69–70; vol. III, pp. 13, 17; vol. IV, pp. 50, 61, 166;
T. Hodgkinson, 'An Ingenious Man for Carving in Ivory', *Victoria and
Albert Museum Bulletin*, vol. I, no. 2, 1965, pp. 29–32.

No. 1

David LE MARCHAND
1674–1726

MATTHEW RAPER
(1704–78)
1720

Relief in ivory.
H. 7$\frac{15}{16}$ in. (20·2 cm.).
W. 6$\frac{3}{16}$ in. (15·7 cm.)
A.20—1959

Inscribed on the back:
Eff. Mathei RAPER juni
Aetat. suae 15° AN.
ad Viũ Scul. D.L.M. 1720

The subject, in high relief, stands with his right foot advanced. He wears a wig, an unbuttoned jacket over a pleated shirt with a stock, and has a cloak draped over his left shoulder and across his legs. In his right hand he holds a quill; his left, with forefinger extended, rests on a three-legged table, on which are geometrical instruments. In the background are a book-case and a draped curtain. As the surface of the panel slopes forward at the bottom, the carver was able to attempt an effect of perspective in his treatment of the interior, and to turn the whole into a kind of genre piece which appears to be without parallel in England. Its domestic character makes a strange contrast to the baroque treatment of the cloak with its swirling folds.

The young sitter became a sound scholar and an able mathematician, a Fellow of the Royal Society, and author of an *Inquiry into the value of Greek and Roman money*, 1771. He lived at Thorley Hall, Hertfordshire, where he had an observatory.[1]

[1] T. Hodgkinson, 'An Ingenious Man for Carving in Ivory', *Victoria and Albert Museum Bulletin*, vol. I, no. 2, 1965, pp. 29–32.

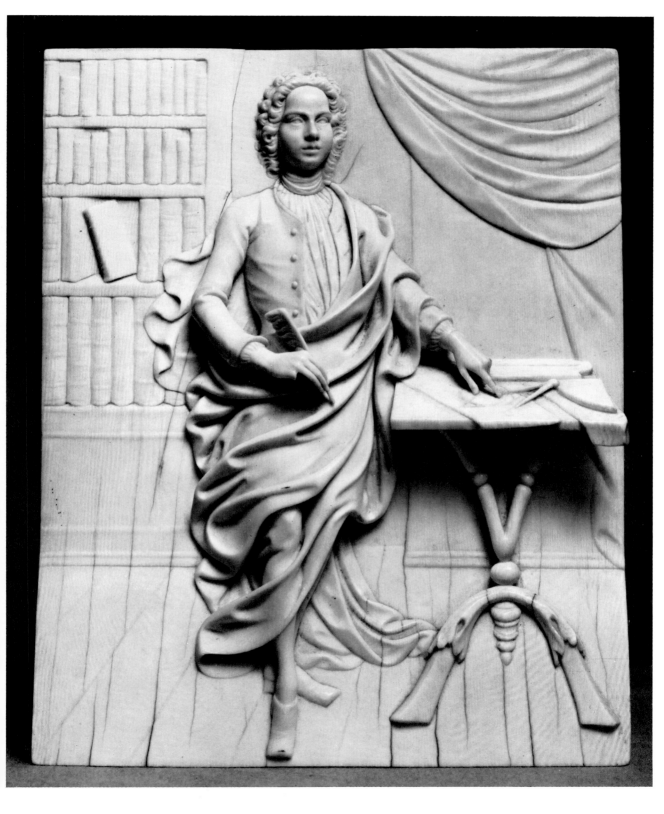

No. 2

David LE MARCHAND
1674–1726

TIME AND
OPPORTUNITY AND
PENITENCE
Probably first quarter of
the eighteenth century

Group in ivory.
H. (to forelock of
Opportunity)
8 in. (20·3 cm.)
A.1—1935.
Given by Dr W. L.
Hildburgh, F.S.A.

Signed: D.L.M.Sc.

The winged figure of Time seizes the half-nude figure of Opportunity, who, taking her own forelock in her right hand, plunges an arrow into her heart. Below crouches the draped female figure of Penitence, leaning on a lion and looking up at the dying Opportunity with an expression of grief. The idea behind the group is of Opportunity lost by the interference of Time, thus resulting in a feeling of Penitence.

The composition is directly adapted from the marble group by Thomas Regnaudin at Versailles (1678) usually called 'The Abduction of Cybele by Saturn', the model of which was afterwards exhibited in the Salon of 1699 as 'Truth unveiled by Time'.[1] It seems probable that it was this model which inspired Le Marchand, though its title does not, in fact, fit the iconography.

Other versions of the composition are known, including one in amber in the Hessisches Landesmuseum at Kassel.[2]

Apart from the fascination of its complex subject, it is not surprising that the group, with its intricate spiral composition, attracted the attention of sculptors working on a small scale, for it gives considerable opportunity for a display of virtuosity, a quality much prized in the early eighteenth century.

[1] R. Wittkower,' Chance, Time and Virtue', *Journal of the Warburg Institute*, vol. I, 1937–38, p. 315 ff., and pl. 49, gives a full discussion of the subject. [2] A. Rohde, *Bernstein*, 1937, pp. 58–9 and pl. 93.

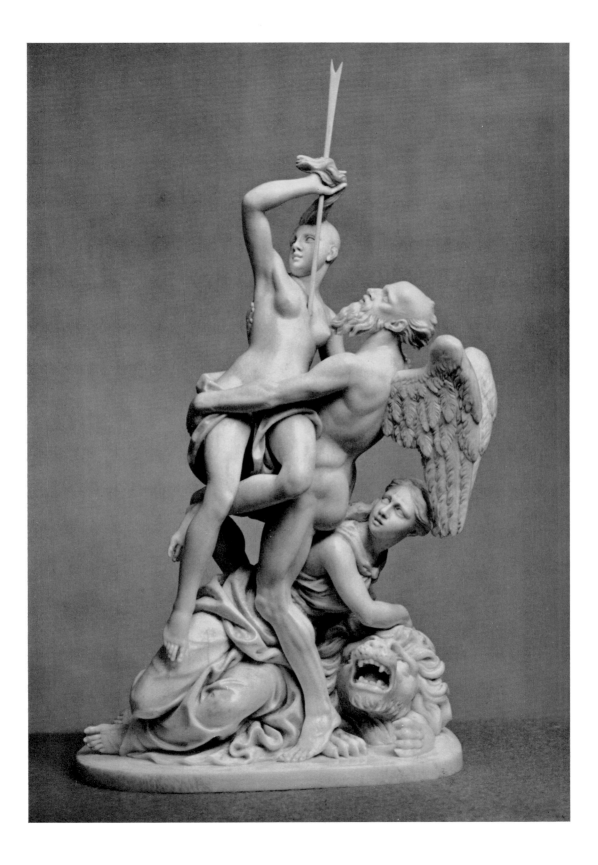

Laurent DELVAUX 1696–1778

Delvaux was born in Flanders, and came to England before 1721 with Peter Scheemakers (q.v.) to work in Westminster Abbey with Denis Plumier on the tomb of John Sheffield, Duke of Buckingham, for which he carved the figure of Time. Like Scheemakers, he worked for a time with Francis Bird before going into partnership with his fellow-countryman. A small number of jointly signed monuments exist which were made before both left for Rome in 1728. Delvaux was to remain there till 1733, when he returned to England for a short time, and then went back to Flanders.

Delvaux was a more talented and a more baroque sculptor than Scheemakers, his soft, rounded modelling being apparent in No. 3. This can also be seen in figures based on the Antique which he executed in Rome for the Duke of Bedford, and which are still at Woburn. His later work in Flanders, such as the pulpit in the Cathedral of Ghent (1745), reveals that he had moved very far from the rigid cult of Antiquity which characterizes most of Scheemakers' work.

G. Willame, *Laurent Delvaux*, 1914; M. D. Whinney, *Sculpture in Britain, 1530–1830*, 1964, pp. 92–5.

No. 3

Laurent DELVAUX
1696–1778

VERTUMNUS AND POMONA
About 1725

Group in marble.
H. 4 ft 3 in. (129·5 cm.).
L. (of base) 2 ft 7½ in. (80 cm.).
W. (of base) 2 ft 1 in. (63·5 cm.)
A.1—1949
Given by Dr W. L. Hildburgh, F.S.A.

Inscribed on ribbon at right side of base: L. Delvot

Pomona is seated on an ivy-clad tree-stump, leaning slightly to her left and supporting herself on her left arm. Her right arm, passing across drapery on her lap, rests on a basket of fruit and flowers, placed above the figure of Cupid seated on the ground on her left. He holds a bow in his right hand and sucks the forefinger of his left. His quiver of arrows lies on the ground, its ribbon falling over the edge of the base. Vertumnus, with drapery over his left shoulder, advances from Pomona's right. He leans forward, touching her right arm, while in his left he holds a mask which he has just removed. The subject is taken from Ovid (*Metamorphoses*, 14, 623 ff.) and shows the wooing of Pomona by Vertumnus, a nature god who had the power of transforming himself into any shape.

The group was made while Delvaux was working in partnership with Peter Scheemakers. Two years before they left for Rome in 1728 they had sold their collection of models, which included one for this group and another of Apollo and Venus. The marbles were almost certainly made for the luxurious house built by James Brydges, Duke of Chandos, at Canons near Edgware, which was pulled down in the mid-eighteenth century. At some date before 1773 they were transferred to Stowe House, Buckinghamshire (see No. 15), though they do not appear in descriptions published before that date. Both groups were in the Stowe Sale of 1848, but were evidently bought back by the family, for they reappeared in the later Stowe Sale of 1921. The catalogue entries are confused, but it would seem that the *Vertumnus and Pomona* was sold at that time, though under the name of the companion piece, *Venus and Adonis*. This second piece, which should perhaps more properly be described as Venus and Apollo, is almost certainly the work of Peter Scheemakers, and is now in a private collection. The *Vertumnus and Pomona*, though a little loose in design and in the balance of the group, is competently modelled with soft rounded forms for the semi-nude figures, while the fluttering drapery with its deep folds shows that Delvaux was more baroque in his style than his partner, Peter Scheemakers.

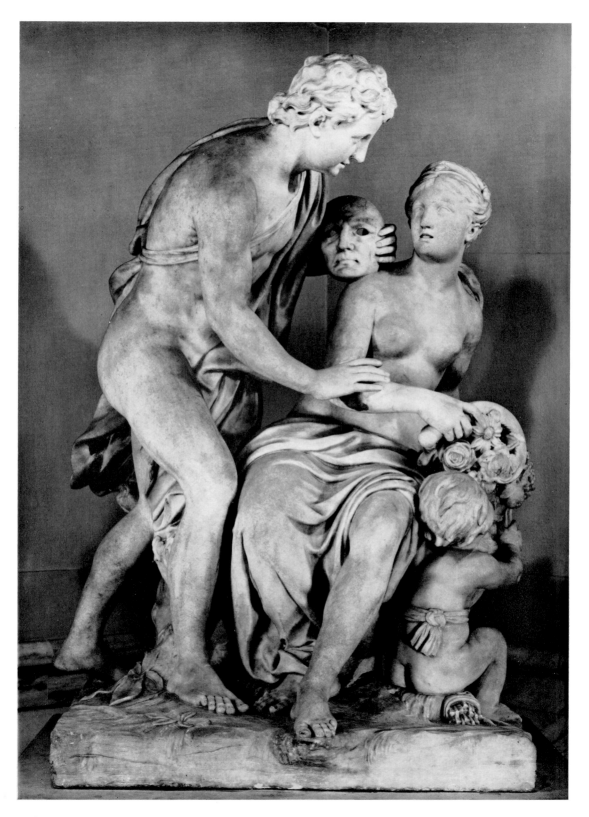

C

John Michael RYSBRACK 1694–1770

Rysbrack, who never seems to have used his first name, was born in Antwerp, the son of a landscape painter who had worked in both England and France. Michael was almost certainly apprenticed to Michael Vervoort or Van der Voort, an Antwerp sculptor who had spent some years in Rome. He came to England about 1720 and remained here till his death. He never visited Italy, so his knowledge of Antique sculpture, for which he had great admiration, was based mainly on engravings and on casts, a number of which were available in England in the early eighteenth century; though he doubtless also saw the few examples of antique sculpture (some of questionable authenticity) which could be found in English collections. He built up a good practice very soon after his arrival, making busts, monuments, reliefs for chimney-pieces and a few statues; and though his fortunes fluctuated slightly, his output throughout his life remained large, and he was always regarded as one of the leading sculptors of his day.

His style naturally varies during a working life of nearly fifty years, but it is basically a combination of the bold and lively modelling of the Antwerp baroque school with an admiration for the designs and, so far as he knew it, the style of Antiquity.

M. I. Webb, *Michael Rysbrack*, 1954; M. D. Whinney, *Sculpture in Britain, 1530–1830*, 1964, pp. 83–91, 116–19.

No. 4

John Michael
RYSBRACK
1694–1770

CANON EDWARD
FINCH (d. 1737)
1728

Bust in terracotta.
H. 2 ft 0 $\frac{5}{16}$ in. (61·8 cm.)
A.27—1939

Inscribed on the back:
Michael Rysbrack. F.1728

The sitter, who looks slightly to his right with head raised, is wearing a soft cap and the gown and bands of a Doctor of Divinity.

Canon Finch was the son of Rysbrack's earliest patron, Daniel Finch, 2nd Earl of Nottingham, whose bust, made before 1723 and now in the possession of Mr G. S. Finch, is a landmark in English sculpture, since it is the first bust made in England in the antique manner.[1] The Canon's bust, slightly later than his father's, but still an early work, is on the other hand an admirable example of a bust in contemporary dress. The strong features, very like those of the Earl, are boldly but at the same time sensitively modelled, the eyeballs are incised, giving the face great liveliness, and the straight-falling folds of the drapery are sufficiently varied to avoid monotony. The bust is connected with the monument in York Minster to Canon Finch (d. 1737) and his brother, Dean Finch (d. 1728).[2] Signed by Rysbrack but not dated, this monument has two marble busts flanking an urn, that of the Canon being on the right. The shoulders and drapery are identical with the terracotta, but the cap has been abandoned, and the Canon appears bare-headed, with short hair in thick waves. The features seem a little fuller and, as so often happened when a terracotta was translated into marble, the incised eyeballs have been replaced by the blind eye, which was thought to have the authority of antiquity.

The monument may have been planned at the time of the Dean's death in 1728 and the bust of his brother then made from the life, but altered when it was translated into marble. Vertue[3] records a marble bust of Dr Finch in Rysbrack's studio in 1732, but this could have represented either of the brothers.

[1] Vertue, vol. III, pp. 17, 56; M. I. Webb, *Michael Rysbrack*, p. 51 and fig. 6; M. D. Whinney, *Sculpture in Britain* 1530–1830, 1964, p. 85 and pl. 59a. [2] J. B. Morrell, *York Monuments*, n.d., p. 40 and pl. xxxvi. [3] Vertue, vol. III, p. 56.

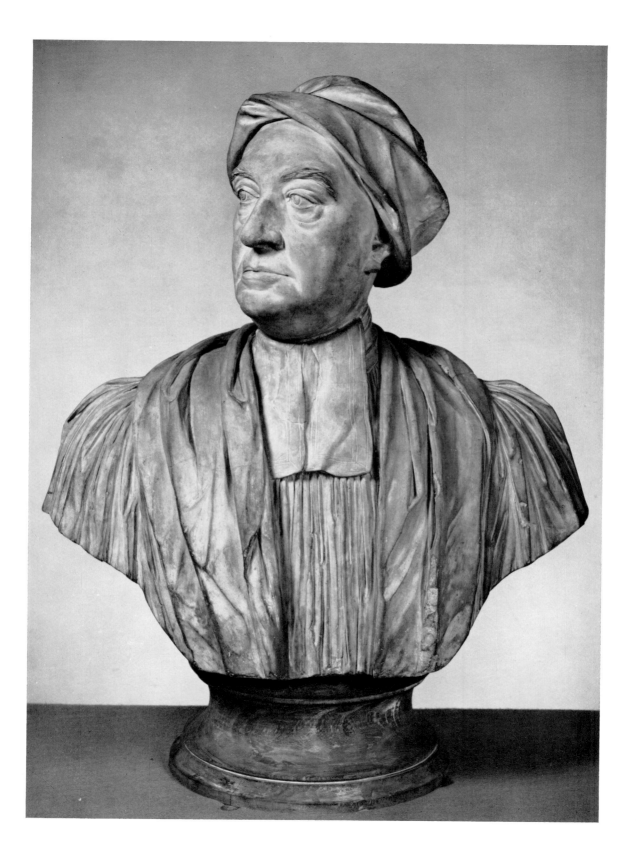

No. 5

John Michael RYSBRACK
1694–1770

SIR ISAAC NEWTON
(1642–1727)
About 1730

Statuette in terracotta.
H. 1 ft 1$\frac{15}{16}$ in. (35·4 cm.).
L. 1 ft 8$\frac{13}{16}$ in. (52·9 cm.).
W. 9 in. (22·9 cm.)
A.1—1938
Given by Dr W. L.
Hildburgh, F.S.A.

Newton is shown reclining on an oblong plinth, resting his right arm on a pile of books. His head is turned to his right, and his left hand is raised. He wears ample draperies over classical dress.

The monument to Newton (Fig. 2) in the nave of Westminster Abbey, finished in 1731,[1] was commissioned by Sir John Conduitt, who had married the scientist's niece, and had succeeded him as Master of the Mint. It is signed by both Rysbrack and the architect and painter, William Kent, who had designed it. Drawings by both architect and sculptor, in the Department of Prints and Drawings of the Museum, and also in the British Museum,[2] suggest that Rysbrack improved the somewhat loose grouping of the design by Kent. Although the upper part of the monument in the Abbey is now masked by the nineteenth-century Gothic screen by Blore, and the effect of the whole considerably marred, it is still possible to realize that it is one of the finest as well as one of the most baroque monuments in the Abbey. The diagonals, which are the basis of the whole design, can easily be traced in the model of the central figure, but the gesture of the left hand, counter-balancing the main lines of the figure, and echoing the angle of the head, only reveals its final meaning in the marble; for Newton is pointing to a scroll, on which is a diagram of the solar system, held up by two boys.

There are small differences between the model and the marble: the arrangement of the pile of books has been changed, giving a stronger support, and the folds of the drapery, as might be expected, are a trifle harder. But both model and marble give an immensely distinguished representation of one of the greatest men of the age. Rysbrack had in all probability never seen Newton in life, but he had almost certainly made his death mask in 1728[3] and would also have known portraits made from the life by Kneller and Thornhill. Only a sculptor of exceptional skill and imagination could, however, have created so vivid and impressive a figure from such sources. Moreover, the discreet use of classical dress gives it a timeless quality appropriate to the genius of the subject.

[1] Vertue, vol. III, pp. 50–1; *Gentleman's Magazine*, April 1731, p. 159; M. I. Webb, *Michael Rysbrack*, 1954, pp. 82–5 and fig. 19; M. D. Whinney, *Sculpture in Britain 1530–1830*, 1967, p. 89 and pls 64 and 65. [2] M. I. Webb, *op. cit.*, figs 22 and 23. See also Physick, pp. 80–1. [3] M. I. Webb, *op. cit.*, p. 78.

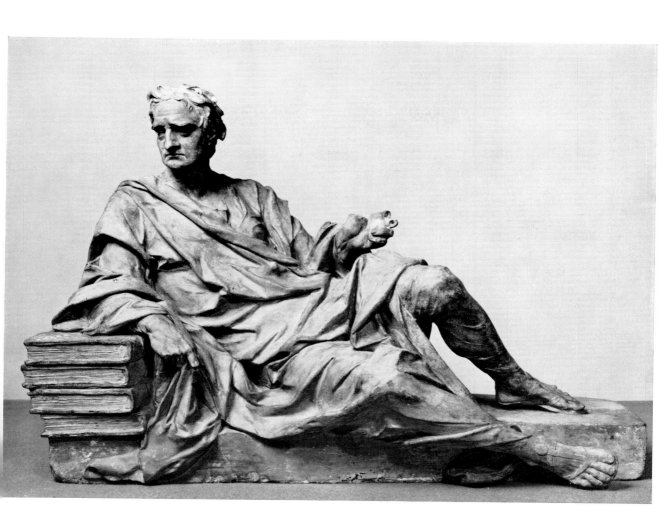

No. 6

John Michael RYSBRACK
1694–1770

THOMAS WENTWORTH, 3rd EARL OF STRAFFORD
(1672–1739)
About 1740

Statuette in terracotta.
H. 2 ft 0⅜ in. (61·9 cm.)
A.1—1954
Given by Dr W. L. Hildburgh, F.S.A.

The subject, in Roman armour under a cloak brooched on his left shoulder, stands with his weight on his left leg, the right leg being forward and slightly bent at the knee. The right arm (the hand of which is now missing) is above a broken column, and the left is bent with the hand catching the cloak on the left hip.

The work is a model for the marble statue of the Earl of Strafford (d. 1739) at Wentworth Castle, which is now much weathered and in which the left hand also is broken. Rysbrack has, however, made important changes in the finished work, which help to give a better balance to the figure. The action of the legs is reversed, the weight resting on the right leg which, with the broken column, gives a strong vertical on that side of the figure, instead of the weak, broken lines of the model. The cloak has also been re-arranged, and is now brooched on the right shoulder, from which slanting folds run down to the bent left arm. Owing to the present condition of the marble, it is unfair to judge the head, but the features appear to be less idealized than in the model.

Rysbrack used much the same pose for two other standing figures made about this time, that of Sir Hans Sloane (c. 1737) in the Physick Garden at Chelsea, and that of George I (1739), now in the Old University Library, Cambridge.[1] The former is in contemporary dress, but the latter, in Roman armour, is very close to the Strafford.

It is surprising, in view of his good Continental training, and his very real ability as a sculptor, that Rysbrack's standing figures should be relatively undistinguished, and above all that, even in a model, he should produce a figure with such an uneasy stance and weak design as the Strafford statuette. On the other hand it is a good example of his bold, incisive manner when working in clay and of his complete control of the formula of classical dress.

[1] M. I. Webb, *Michael Rysbrack*, 1954, pp. 158–62.

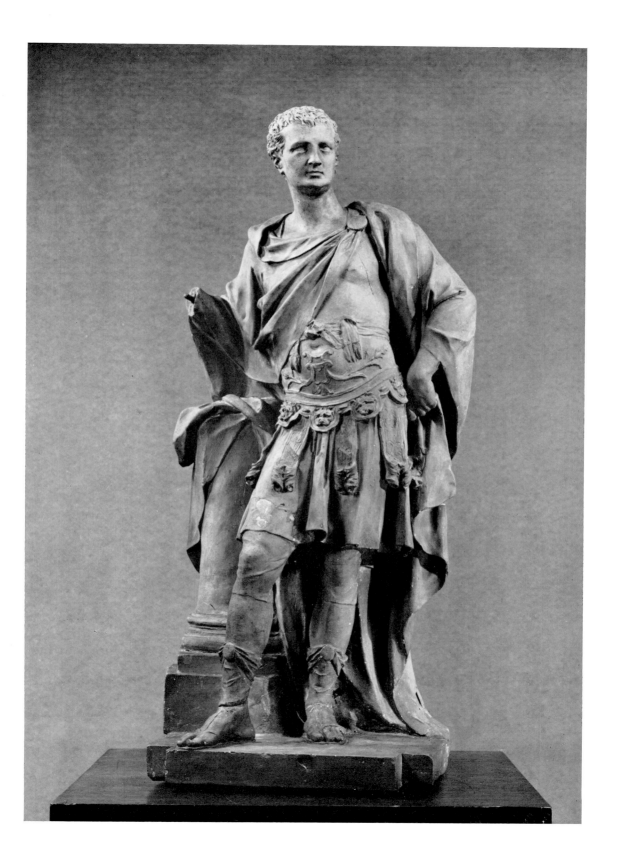

No. 7

John Michael RYSBRACK
1694–1770

AN ALLEGORY OF CHARITY
About 1746

Relief in painted terracotta.
H. 2 ft 2⅜ in. (67 cm.).
W. 3 ft 5½ in. (105·4 cm.)
A.58—1953

Inscribed: Mich: Rysbrack

The relief, which is a model for a marble chimney-piece presented by Rysbrack to the Foundling Hospital in 1746, shows Charity standing to the left of centre, suckling a child, while another child clutches at her robe. To the left, at the base of a tree, three children are coiling the rope of an anchor, the stern of a ship appearing in the background. In the centre of the relief a kneeling woman milks a cow, and to the right two children are gathering sheaves of corn.

The Foundling Hospital, established by Captain Coram in 1740, had already received an important gift from William Hogarth and was soon to receive gifts from other leading artists, among them Hayman, Highmore, Hudson, Allan Ramsay and Richard Wilson, who like Rysbrack were elected Governors. It therefore became, before the foundation of the Royal Academy in 1768, an important exhibition of contemporary art. The building was demolished in 1928, but all the works of art, including Rysbrack's chimney-piece, were moved to the Thomas Coram Foundation for Children, 40 Brunswick Square, W C 1, which is occasionally open to the public.

Rysbrack's gift is described in 1746 in the *Note-books of George Vertue*,[1] who adds: 'the Moddel of Clay of the same magnitude is admirably well done and therein shows his great Skill in the plastic Art wherein as the Materia is moleable, still permitts the Artist to express his mind more Artfully and with greater freedom. than on the laborious or durable marble'—Vertue, himself an engraver of accomplishment, knew many of the artists of his day intimately, and must often have watched the loss of vitality when a clay model was translated into marble or stone. In this case the design in the marble is identical, but some of the delicate modelling, so marked in the relief, is lacking.

The model was bought from Rysbrack by Sir Edward Littleton for his new house, Teddesley Hall near Stafford, and the sculptor supplied a drawing for a frame and the fireplace below in 1756. There are drawings by Rysbrack for chimney-pieces at Teddesley Hall in the Department of Prints and Drawings.[2] Several letters from the artist to this patron[3] refer to the relief of Charity, notably that of 7 April 1761, when Rysbrack wrote: 'Sir, I am sorry for the accident which has happed to the Model, of the horn of the Cow. The Horn is broke likewise of ye Marble Basso Relievo at the Foundling hospital, but it looks the more antique as Doctor Mead said of it. the accident may be repaired, by modelling the horn in Clay, and making a Mould upon it, and Cast it in Plaster of Paris, fix it on. and Paint it of the same colour as the Model is.' In the relief, which is known to have come from Teddesley Hall, the damage to the projecting horn of the cow may still be seen.

It is characteristic of Rysbrack's day that any resemblance to the antique, even through damage, should be regarded as advantageous. In fact, the Charity is among the least antique of Rysbrack's works. It

[1] Vertue, vol. III, p. 132; M. I. Webb, *Michael Rysbrack*, 1954, pp. 131–35. [2] Physick, pp. 101–03. [3] Letters published by K. A. Esdaile, *The Art of John Michael Rysbrack in Terracotta*, 1932; and M. I. Webb, *Michael Rysbrack*, 1954, Appendix 1.

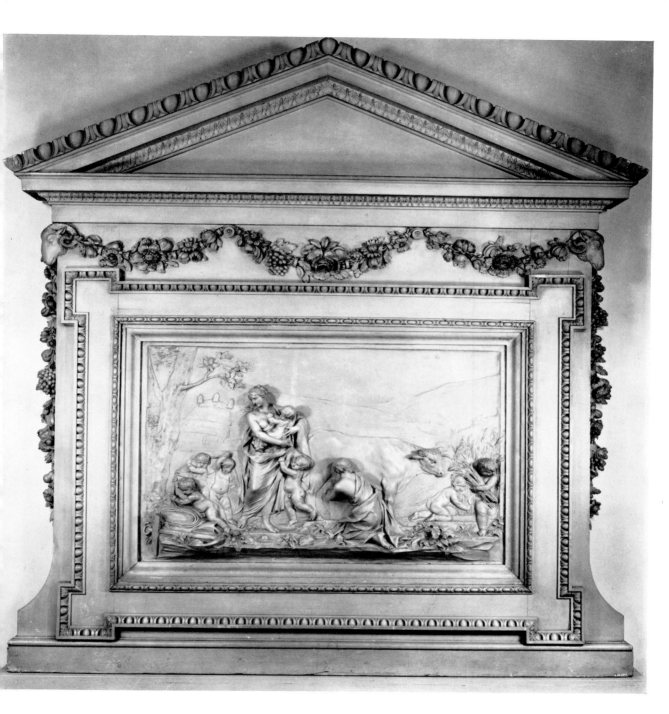

has not the force and grandeur of his reliefs directly based on the antique, such as the chimney-pieces at Houghton Hall, Norfolk, or Clandon Park, Surrey. In them the figures are boldly silhouetted against the ground, and the setting is simple. Here the treatment of landscape and figures alike is more pictorial, the surface modelling is more delicate, and the whole is broken up into smaller areas of light and shadow. Like the statuettes of Rubens and Van Dyck (Nos. 8 and 9), from the same period of Rysbrack's life, it proves with its rustic charm that he was not untouched by the rococo.

No. 8

John Michael
RYSBRACK
1694–1770

SIR PETER PAUL
RUBENS (1577–1640)
After a model of 1743

Statuette in bronze.
H. 1 ft 11¾ in. (60·3 cm.)
A.24—1955
Bought with the
assistance of a friend of
the Museum

Inscribed: D PETRVS
PAVLVS RVBBENS
EQVES and Miche
Rysbeack 1749 [sic].
Faintly incised: L.
Genneau

The subject, in early seventeenth-century costume with lace collar and cuffs, stands with his weight on his right leg, the left bent at the knee. An antique medallion is suspended on a chain running across his chest and over his left shoulder. He places his right hand on his heart, while his left touches the hilt of his sword. Behind and to the left is a half-column, draped with a fringed and embroidered coverlet.[1]

This elegant conception and the companion piece of Van Dyck (see No. 9) date, like the relief of Charity (see No. 7), from that phase of Rysbrack's life when his style shows a marked leaning towards the rococo.[2] Vertue relates[3] that, after the enormous success of Peter Scheemakers's Shakespeare monument in Westminster Abbey, completed in 1740, Rysbrack's practice declined, and, having leisure, he turned his attention to a small number of works which were not, apparently, commissions. These included statuettes of his two famous countrymen together with a third of the Flemish sculptor, François Duquesnoy, who worked long in Italy, and was commonly known as Fiammingo. All have the new elegance of this phase of Rysbrack's art. This is indeed peculiarly suited to early seventeenth-century costume, which, to Englishmen, recalled the court circle of Charles I, as portrayed by Van Dyck. And all, to a greater or less degree, make use of the looped cloak, counterbalancing the gesture of the hands, which is a notable feature of Scheemakers's *Shakespeare*, the result probably of the fact that the designer was William Kent, a far more baroque artist than Scheemakers. The whole surface of Rysbrack's *Rubens*, perhaps more than any other of his works, is broken up into small areas of light and shade, giving the quick and rippling modulations characteristic of rococo art.

A number of versions of these figures exist. A terracotta of Rubens belonging to the Earl of Harrowby is signed and dated 1743. The designs were evidently popular, for Vertue records[4] in 1747 that Rysbrack was selling casts of them at seven guineas the set. They would, indeed, have made most attractive ornaments for a gentleman's

[1] For the use on other works of this coverlet, which was clearly one of the artist's studio properties, see M. I. Webb, *Michael Rysbrack*, 1954, pp. 94–5. [2] M. D. Whinney, *Sculpture in Britain, 1530–1830*, 1964, p. 116. [3] Vertue, vol. III, p.116. [4] Vertue, vol. III, p. 135.

library.[5] They were copied by other sculptors, examples signed by John Cheere and dated 1749 being in the City Art Gallery, York, and with some modifications were used by Verskovis for the ivory figures on Horace Walpole's Cabinet, now in the Museum.[6]

'L. Genneau', which is incised on the Museum's bronze version of the *Rubens*, is presumably the name of the caster. His dates are unknown; but the possibility that Nos. 8 and 9 are nineteenth-century copies of Rysbrack's models cannot be excluded.

[5] For other versions, see M. I. Webb, *op. cit.*, pp. 109, 110, 224, 226; F. J. B. Watson, 'A Bust of Fiammingo by Rysbrack Rediscovered', *Burl. Mag.*, vol. CV, 1963, pp. 441–45. The pair now in the Museum were formerly in the Hospital of St John and St Elizabeth, London. [6] The ivory figures are of Fiammingo, Inigo Jones, and Rubens, though the last has the body copied from the full-size statue by Rysbrack of Palladio at Chiswick (M. I. Webb, *op. cit.*, p. 112 and fig. 42).

No. 9

John Michael
RYSBRACK
1694–1770

SIR ANTHONY VAN
DYCK (1599–1641)
After model of about 1743

Statuette in bronze.
H. 1 ft 11$\frac{3}{16}$ in. (58·9 cm.)
A.23—1955
Bought with the
assistance of a friend of
the Museum

The subject is in early seventeenth-century costume (often known in the eighteenth century as 'Van Dyck dress'), and with his weight on his left leg turns slightly to his right. He holds his cloak against his hip with his bent right arm, the left being extended free of the body. Behind is a half-column draped with a plain coverlet, and on the plinth lie a scroll, a painter's palette and brushes, and an antique medallion on a scroll.

This figure makes a pair with the Rubens (see No. 8), but it is not inscribed, and is less accomplished in the surface chasing. The pupils of the eyes are left blank, whereas in the Rubens they are incised. Moreover, the coverlet is plain and not embroidered. Terracotta versions of the Van Dyck are, however, known with the embroidered coverlet, as used in the Rubens.[1]

[1] One was sold at Sotheby's, 4 December 1956, lot 99. See also the references quoted under No. 8.

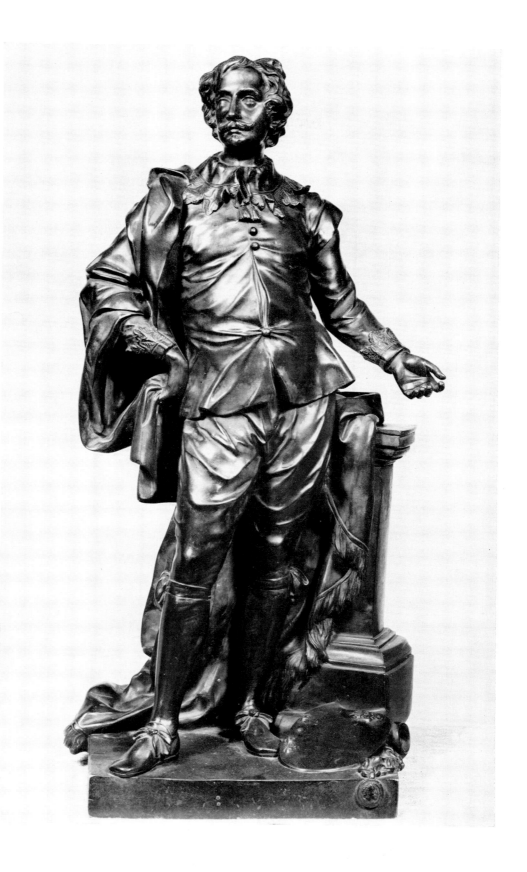

No. 10

John Michael
RYSBRACK
1694–1770

JOHN LOCKE
(1632–1704)
1755

Statuette in terracotta.
H. 1 ft 11 in. (58·4 cm.)
33—1867

Inscribed on left side of
base: Mich: Rysbrack:
1755

The statuette is a model for the statue of the philosopher, given to Christ Church, Oxford, where he had been educated, in 1759 by William Lock, who claimed to be a relative.[1] It shows the subject standing bareheaded, in flowing robes, his weight on his left leg, his right hand supporting a book which rests on his right thigh, the right leg being bent at the knee. According to the Chapter Minutes of Christ Church the gift was proposed in 1754, but Rysbrack refers to it in a letter in 1756 as still unfinished. It was placed in position in 1758, and Rysbrack's account for the pedestal is dated 1759.[2] The statue was originally in a niche half-way up the library staircase, but has since been moved to the top niche. The terracotta statuette is probably that listed on the second day of Rysbrack's Sale on retirement (25 Jan. 1766, Lot 56). In general lines it is very close to the marble, but the relative size of the head is slightly greater, and the expression is more serious and less transient. This is one of the grandest works of Rysbrack's later years. The slightly rococo phase of the 1740s represented by the figures of *Rubens* and *Van Dyck* (Nos. 8 and 9) and the relief of *Charity* (No. 7) has passed, and the general feeling is closer to the nobility of the Newton monument (No. 5 and Fig. 2). Moreover, like the Newton effigy, the figure is built up on a series of diagonals, and the drapery folds are even more deeply cut. Rysbrack had never been to Rome and so cannot have known the standing figures of the late baroque, such as the series of Apostles in the nave of St John Lateran of about 1718. But his work here belongs to that tradition, and suggests that, if large-scale religious statues had been required in England, Rysbrack's talent could have been well employed in making them.

[1] W. G. Hiscock, *A Christ Church Miscellany*, 1946, p. 82. [2] All the documents, including Rysbrack's letter mentioning the statue, are given in M. I. Webb, *Michael Rysbrack*, 1954, pp. 169, 195.

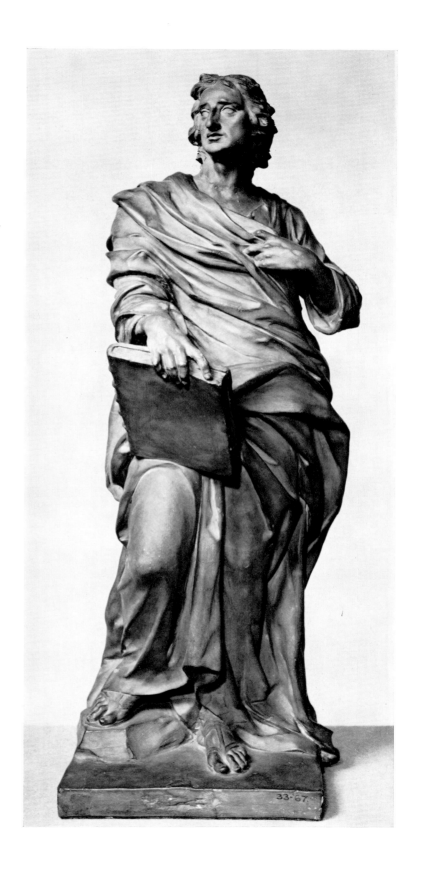

D

No. 11

**John Michael
RYSBRACK**
1694–1770

FLORA
1759

**Statuette in terracotta.
H. 1 ft 10 9/16 in. (57·3 cm.)
A.9—1961
Purchased under the
Bequest of Dr W. L.
Hildburgh, F.S.A.**

**Inscribed: Mich:
Rysbrack Fe^t: 1759**

The figure is based on the Farnese *Flora* (Museo Nazionale, Naples), casts of which are known to have been in England in Rysbrack's day. She wears a classical garment, held on the hips by a narrow knotted belt, and with a cloak over her left arm. Her weight is on her right leg, the left being bent at the knee. In her left hand she holds a wreath of flowers, now broken, and her right arm, which in the original falls by her side holding up the hem of her garment, is broken off above the elbow.

This terracotta is a model for the marble *Flora*, finished in 1761 and made by Rysbrack for Henry Hoare and still in the Pantheon at Stourhead, though it appears from the sculptor's letters of 1758 to another patron, Sir Edward Littleton, who eventually bought this model, that more than one model was made.[1] It differs at a number of points from the antique original, for the figure is slighter in build; the movement of the legs, which affects the balance of the whole body, is more pronounced and the curves of the drapery patterns are strengthened. In other words, it is given an elegance which betrays its eighteenth-century origin.

The figure was copied at the porcelain factory at Bow, in both coloured and white porcelain, an example of the former being in the Museum.[2] A small plaster version, in which the right arm and the wreath of flowers is complete, is in the Soane Museum.

[1] K. A. Esdaile, *The Art of John Michael Rysbrack in Terracotta*, 1932, p. 42; M. I. Webb, *Michael Rysbrack*, 1954, pp. 126, 199, 202. [2] R. J. Charleston and Geoffrey Wills, 'The Bow "Flora" and Michael Rysbrack', *Apollo*, April 1955. p. 125.

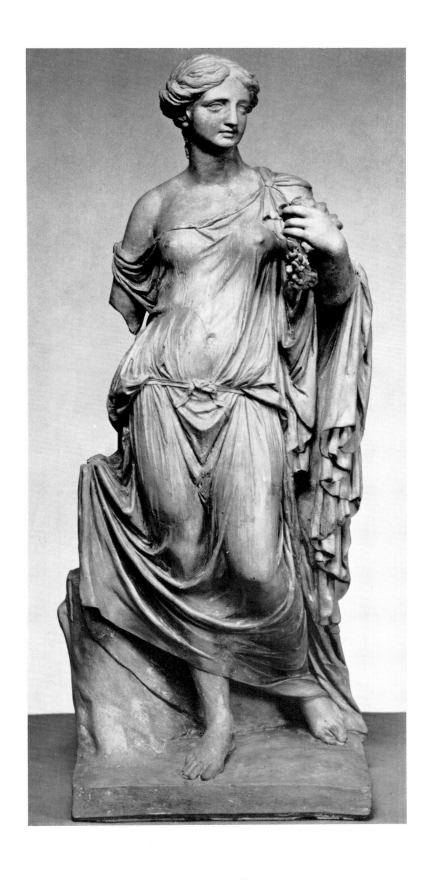

No. 12

John Michael RYSBRACK
1694–1770

KING GEORGE II
(1683–1760. Succeeded 1727)
1760

Bust in marble.
H. 2 ft 11¼ in. (89·5 cm.)
A.10—1932

Inscribed on the back:
M.R. Sculp.ᵗ 1760

The head, crowned with a laurel wreath, is turned slightly to his right; the King wears fantastic armour with a Field Marshal's scarf, the Star and the Garter on his breast, and the jewel of the Garter on a ribbon round his neck. The armour is ornamented with lion mask pauldrons and a Medusa head.

Although the bust dates from the last year of the King's life it does not seem to show him as a man of nearly eighty, but is a variant of a bust made from life in 1738.[1] Both the terracotta and the marble of the 1738 bust are at Windsor Castle.[2] In the Museum's bust the dress is almost identical, but the wig is shorter and the face a trifle older.

George II no doubt liked this military image, for he was more interested in public affairs than he was in the arts, and was, indeed, the last English King to lead his troops into battle—at Dettingen in 1743. The bust, which shows no flagging of the artist's hand, is characteristic of his ability to make a lively portrait out of whatever material came his way, and also of his command of fine, decorative detail.

[1] Vertue, vol. III, p. 84. [2] M. I. Webb, *Michael Rysbrack*, 1954, pp. 155–56, 216, figs 73 and 74. A further bust, also at Windsor, was placed in the 'new Library in St James, Green Park' in 1739 (K. A. Esdaile, *The Architect*, vol. CVII, 1922, p. 249 ff.).

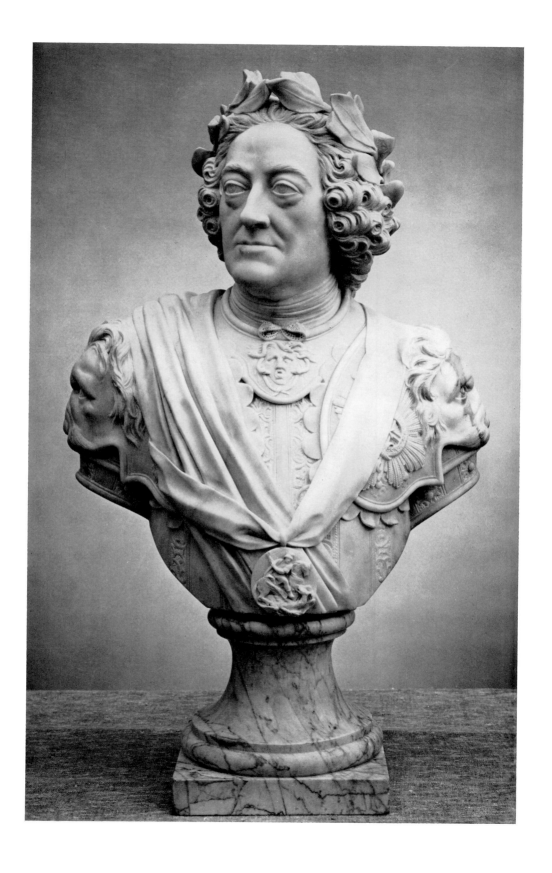

No. 13

John Michael RYSBRACK
1694–1770

FAME
1760

Statuette in terracotta.
H. 1 ft 10⅞ in. (58·1 cm.)
A.1—1969

Signed and dated on the base: Mich:[1] Rysbrack fecit 1760

Fame, wearing a classical tunic with a cloak over her left shoulder, advances rapidly towards the right, her head being turned in profile and her drapery blown against the figure. Both arms, her wings and her left foot, which is hidden by drapery, are broken.

The statuette is a model for the marble monument to Admiral Vernon in Westminster Abbey. Admiral Edward Vernon (1684–1757), Admiral of the White, the son of James Vernon, Secretary of State to William III, had distinguished himself in the Caribbean during the war with Spain in 1739. The monument, erected by his nephew, Lord Orwell, in 1763, is badly placed on the north wall of the north transept (Fig. 5). It is one of Rysbrack's last works and the one in which the influence of Roubiliac is most clearly apparent. Fame is about to crown the bust of Vernon, shown in classical dress, with a wreath of laurel, but the design is asymmetrical, for there is no figure to balance her beyond the bust, but only a pile of trophies. Moreover, this is one of the few occasions on which Rysbrack attempted a figure in movement.[1]

The marble is very close to the model, though the swiftness of the movement has been calmed, chiefly by a change in the angle of the head; and the draperies, which are almost rococo in their small areas of light and shade, are somewhat hardened on the monument. There is a drawing for this monument in the Department of Prints and Drawings.[2]

[1] M. I. Webb, *Michael Rysbrack*, 1954, pp. 91, 167, 226. [2] Physick, p. 108, fig. 73.

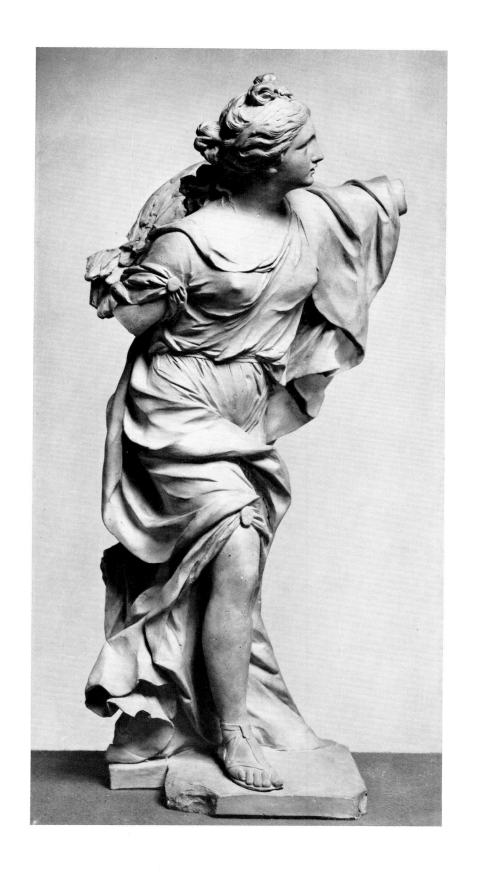

Peter SCHEEMAKERS 1691–1781

Scheemakers, the son of an Antwerp sculptor, came to England at some time before 1721 to work with Denis Plumier on the tomb of John Sheffield, Duke of Buckingham, in Henry VII's chapel, Westminster Abbey. He may possibly have previously visited both Denmark and Italy. After Plumier's death in 1721 he worked for a time with Francis Bird, but by 1725 he was in partnership with his fellow-Fleming, Laurent Delvaux (q.v.) and began to build up a practice in tomb sculpture. In 1728 they went to Rome, where Scheemakers was assiduous in his study of the Antique, bringing back a number of models of famous pieces on his return to England in 1730. He remained in this country till 1771, when he returned to Antwerp, where he died ten years later.

He was a prolific sculptor, turning out monuments and busts in large numbers, some of which are indifferent in quality and were probably executed by one of his many assistants. His best work, however, as can be seen in Nos. 14 and 15, has real distinction. His admiration for Antique art is very evident, especially in work after 1730, his modelling being smoother and more generalized than that of his rival, Rysbrack, whose prices he tried to undercut. Only occasionally, when working in collaboration with another artist, as in his execution of William Kent's design for the Shakespeare monument in Westminster Abbey, does he show any marked tendency towards the baroque. As well as monuments and busts he carried out a certain amount of garden sculpture, some of it directly copied from the Antique, and also made chimney-pieces, an example of the latter being in the Museum. He was undoubtedly a successful, if somewhat repetitive master, satisfying a large number of clients, and his influence was considerable, both in his own day and on the next generation.

M. D. Whinney, *Sculpture in Britain 1530–1830*, 1964, pp. 92–7, 119–21

No. 14

Peter SCHEEMAKERS
1691–1781

DR HUGO
CHAMBERLEN
(1664–1728)
About 1730

Statuette in terracotta.
H. $11\frac{3}{4}$ in. (29·8 cm.).
L. 1 ft $7\frac{1}{4}$ in. (48·9 cm.).
W. $6\frac{1}{2}$ in. (16·5 cm.)
A.6—1927
Given by Dr W. L.
Hildburgh, F.S.A.

The doctor, wearing the robes of the Royal College of Physicians, reclines to the left, resting on his right elbow supported by cushions. His left hand rests on a book upright on his knee.

Dr Hugo Chamberlen was a member of a well-known family of London physicians, his chief interest being midwifery. He had many fashionable patients, and was a close friend of the Duchess of Buckingham and Normanby, whose son erected the monument in Westminster Abbey, for which this is a sketch model. Scheemakers had, some ten years earlier, been employed on the Duke's monument in Henry VII's Chapel in Westminster Abbey. The Chamberlen monument, which according to Vertue[1] was erected in 1731, stands in the north choir aisle of the Abbey (Fig. 1). Below the sarcophagus the monument bears the signature of two sculptors, Peter Scheemakers and Laurent Delvaux, which tallies with Vertue's statement that one of the allegorical figures was by Scheemakers's fellow-Fleming, and also suggests that the work was planned and probably begun in Chamberlen's life-time; for both sculptors went to Rome late in 1728 and, though Scheemakers returned in 1730, Delvaux remained till 1733, that is, till after the monument was erected. The models for the effigy, which Vertue states was by Scheemakers, and for one of the allegorical figures were in a sale of Scheemakers's work in 1756,[2] but unfortunately no description by which the figure can be identified is given.

This terracotta model is among Scheemakers's liveliest and most pleasing works. The marble repeats it almost exactly, though the detail, notably of the head, becomes more generalized, and the folds of the drapery harder and more repetitive. If this figure is compared with Rysbrack's almost contemporary model for the Newton monument (No. 5), the difference between the two sculptors can quickly be seen, above all in the treatment of the drapery. Newton may be wearing classical dress, but the wide variation between big and small folds, and the strong underlying diagonals make his figure fundamentally less classical and more baroque than the *Chamberlen*, in which the smaller repeated folds follow more closely the forms of the body.

[1] Vertue, vol. III, p. 53; K. A. Esdaile, *English Monumental Sculpture since the Renaissance*, 1927, p. 142; M. D. Whinney, *Sculpture in Britain 1530–1830*, 1964, pp. 93, 94. [2] Sale, Wed. and Thurs., 10 and 11 March 1756, Lot 18 on second day.

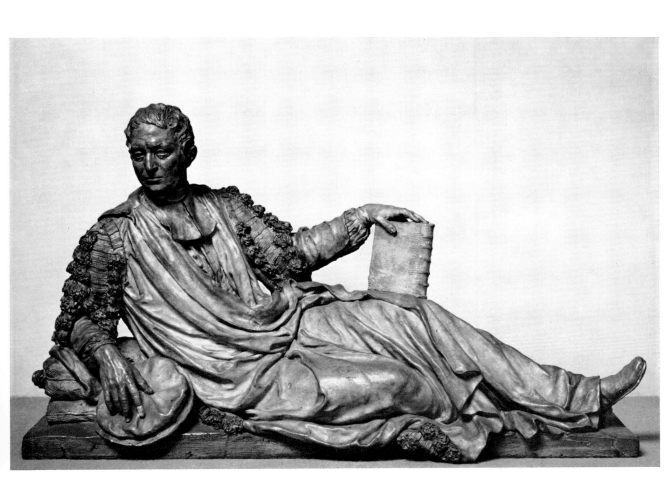

No. 15

**Peter SCHEEMAKERS
1691–1781**

**RICHARD TEMPLE,
VISCOUNT COBHAM
(1669?–1749)
About 1740**

**Bust in marble.
H. (including base)
2 ft 9¼ in. (84·5 cm.)
A.1—1942
Given by Dr W. L.
Hildburgh, F.S.A.**

**Inscribed on right side of
the base: P. Scheemakers
Ft, and on the front
below the sitter's coat of
arms: Rd. Temple
Viscount Cobham**

The sitter looks to his half-left, and wears a fringed toga, caught on his right shoulder with a circular brooch, over a classical tunic. He wears no wig, but has short hair in the antique manner, and his eyeballs, unusually for Scheemakers, are incised. Lord Cobham, a distinguished Whig, whose portrait is included in Kneller's Kit Kat Series, was a patron of letters and a Field Marshal (1742), but he is chiefly remembered for having rebuilt the great house at Stowe, Buckinghamshire. The gardens, even more famous than the house (which was to be altered by Robert Adam later in the century), were lavishly adorned with small buildings, temples of various kinds, and much sculpture by both Rysbrack and Scheemakers.

This bust was one of the series in the Temple of Friendship, a small Tuscan temple built by James Gibbs in 1739. Vertue,[1] quoting from a guide book to the Gardens published in 1745, lists the subjects of the others as Frederick, Prince of Wales, the Earls of Westmoreland and Chesterfield, Lords Cobham, Gower and Bathurst, Richard (later Earl) Grenville, William Pitt (later Earl of Chatham) and George Littleton, Esq. A guide book of 1756 adds the name of the Earl of Marchmont.[2]

All the busts were sold in 1848, but of Scheemakers's work only the *Cobham* and the *Frederick, Prince of Wales* (now in the Royal Collection) appear to have survived. It is possible, however, that some were made by other sculptors (see No. 18).

The Cobham is an unusually distinguished example of Scheemakers's work, and betrays his first-hand knowledge of good antique busts. The forms are more sensitively modelled than in the majority of his busts, and there is a considerable sense of character. The treatment of the drapery shows an inventive contrast of verticals and looped folds, thus differing from his many busts with looped folds alone. It is a work which can hold its own against the fine contemporary busts by Rysbrack, for though the forms are everywhere a trifle flatter, it is a lively and virile portrait, and encourages the feeling that the many somewhat mechanical busts of Scheemakers may well be partly the work of assistants.

[1] Vertue, vol. III, 133. [2] Stow, *A Description of the Magnificent Gardens . . .*, London, 1756, p. 30.

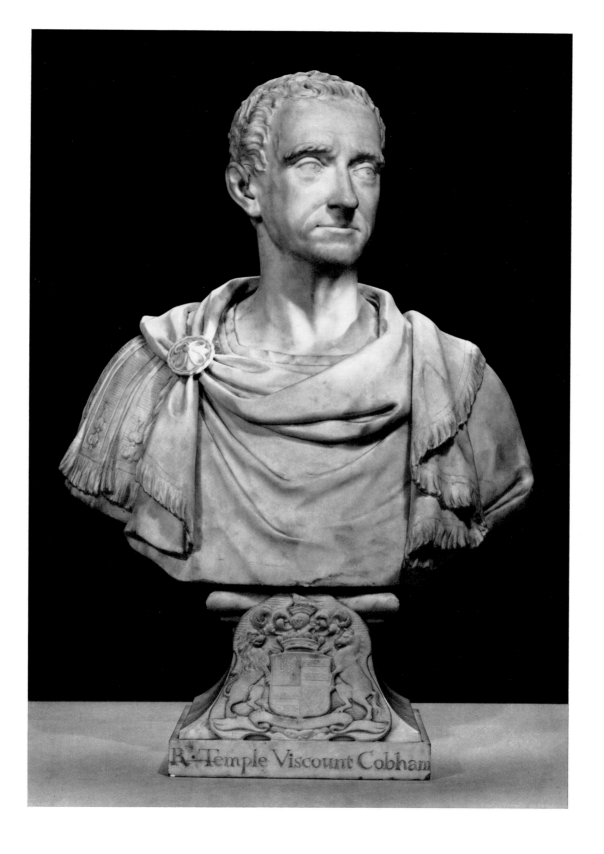
R. Temple Viscount Cobham

Sir Henry CHEERE 1703–81

Cheere was probably of Huguenot extraction, for Vertue always speaks of him as a foreigner, but was apprenticed to the mason-sculptor, Robert Hartshorne. From 1729 to 1733 he worked in partnership with Henry Scheemakers (brother of the better-known Peter Scheemakers), and jointly signed a small number of monuments. Thereafter he worked on his own, obtaining many commissions, especially from the University of Oxford, for statues and busts, while he also made monuments and chimney-pieces. After 1740 he gave time to activities outside sculpture and was clearly something of a public figure, since he was chosen by the County of Middlesex to present a congratulatory address to George III on his accession in 1760. He was rewarded with a knighthood, and granted a baronetcy in 1766. In 1748 he made a trip to Paris with his fellow artists Hogarth, Hudson and the drapery painter Van Aken. In the 1750s he was concerned with abortive attempts to found an Academy of Painting, Sculpture and Architecture and he was the first sculptor to be elected a Fellow of the Society of Antiquaries. His style is more rococo than that of his rivals, Rysbrack and Scheemakers, his drapery rhythms being smaller and lighter, with more use of curling, crumpled edges. In his later monuments he tends to use coloured marble for the background, and much rich but elegant decoration. His brother, John, was also a sculptor, specializing in garden figures and plaster or lead busts, often after other artists, for the decoration of libraries and staircases.

M. I. Webb, 'Henry Cheere, Henry Scheemakers and the Apprenticeship Lists', *Burl. Mag.*, vol. XCIX, 1957, pp. 115–20; 'Henry Cheere, Sculptor and Businessman and John Cheere', *ibid.*, vol. C, 1958, pp. 232–40, 274–79; M. D. Whinney, *Sculpture in Britain, 1530–1830*, 1964, pp. 98–101, 121–24.

No. 16

Sir Henry CHEERE
1703–81 (Attributed to)

LORD CHIEF JUSTICE
RAYMOND (1672–1732)
About 1732

Bust in marble.
H. (including base)
1 ft 11⅝ in. (60 cm.)
A.1—1947
Given by Dr W. L.
Hildburgh, F.S.A.

The bust shows a partly bald man in late middle age with a mole on his left cheek. Shoulders and breast are draped in the classical manner, with a pleated garment showing beneath the cloak. On the back is incised:

ROBERTUS D.nus RAYMOND. Capital.
Justic. Angliae, Obiit XVIII.º Martii
MDCCXXXII
Ætat LX.

Robert Raymond was Lord Chief Justice from 1724 till his death in 1732. He was created Baron Raymond of Abbot's Langley in Hertfordshire in 1730 and is buried in Abbot's Langley Church. His monument, which shows him reclining in his robes and wig, with his wife seated beside him, is signed: Westby Gill A. R. invenit. H. Cheere fecit. Nothing is known of Westby Gill, and the attribution of the bust to Henry Cheere rests partly on his execution of the monument, but also on the rich treatment of the folded drapery, which is quite unlike the handling of either Rysbrack or Scheemakers. The features, with plain eyeballs, seem a little tame compared with the drapery and with other known work by Cheere, and it may well be that the bust was not made from life.

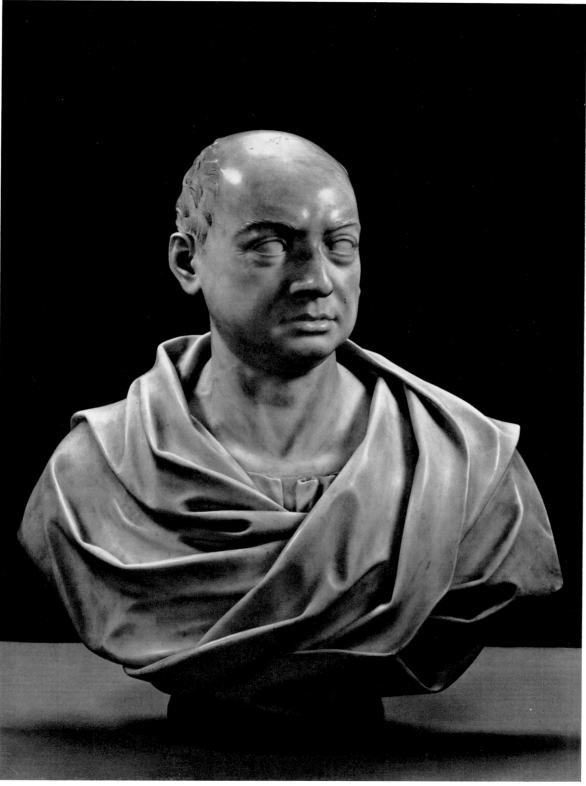

E

Giovanni Battista GUELFI
working 1714– d. 1734

Guelfi, a Bolognese by birth, was trained in Rome under Camillo
Rusconi, a distinguished sculptor in the Berninesque tradition.
Guelfi's work shows little of his master's brilliance, and it is not
known how or why he attracted the attention of Lord Burlington,
who brought him to England in about 1715. He restored the
Arundel Marbles (the collection of antiques made by the Earl of
Arundel in the reign of Charles I), now in the Ashmolean
Museum, Oxford, and made a number of monuments. The most
important of these was the standing, cross-legged figure of James
Craggs (d. 1721) in the nave of Westminster Abbey. This,
designed by James Gibbs, was to prove extremely influential.[1]

His work is, on the whole, stiff and insensitive, and Vertue
suggests that Lord Burlington was disappointed in it, and glad
when he returned to Italy in 1734. Indeed, he was clearly a
tiresome man as well as an indifferent sculptor: 'slow of speech,
much opiniated, and as an Italian thought no body could be equal
to himself in skill in this Country. Yet all his works seem to the
judicious very often defective, wanting spirit and grace. Its
thought that Ld. Burlington parted with him very willingly'.[2]

[1] See Physick, pp. 69–73. [2] Vertue, vol. III, p. 73. For an account of his works,
see M. I. Webb, 'Giovanni Battista Guelfi: an Italian Sculptor working in England',
Burl. Mag., vol. XCVII, 1955, pp. 139–45, 260.

No. 17

**Giovanni Battista
GUELFI
working 1714–d. 1734**

**ANNE, DUCHESS OF
RICHMOND (d. 1722)
About 1734**

**Bust in terracotta.
H. 2 ft 3¼ in. (69·2 cm.)
A.19—1947
Purchased by the John
Webb Trust**

The sitter is turned slightly to her left, and has loose curls falling on her left shoulder. She wears a low-necked dress with a frill at the top, and a jewel in front attached to a ribbon over her left shoulder. Over the dress is a cloak or shawl.

The bust, formerly at Goodwood House, Sussex, is a model for the monument to the Duchess, erected by her son in 1734, and signed: Johannes Baptiste Guelfi Romanes fecit, in Deene Church, Northants.[1] In the monument the bust is set in a distinguished pedimented frame, copied from the frontispiece of Lord Burlington's publication, *Fabbriche Antiche disegnate da Andrea Palladio*, 1730, the design of which by William Kent is said to have been based on a drawing by Palladio himself. The use of the design indicates Guelfi's close links with Lord Burlington's circle. He was not, however, a very distinguished sculptor, for his modelling is smooth and empty, though the terracotta, with lightly incised eyeballs, is a trifle more lively than the marble at Deene. Admittedly, like many busts on monuments, it is probably posthumous, based on portraits, and not done from the life, but other contemporary sculptors frequently showed far greater imagination when faced with this problem, and produced portraits of much more vitality.

[1] K. A. Esdaile, 'Signor Guelfi, an Italian', *Burl. Mag.*, vol. XC, 1948, p. 317; M. I. Webb, 'Giovanni Battista Guelfi: an Italian Sculptor working in England', *ibid.*, vol. XCVII, 1955, p. 143.

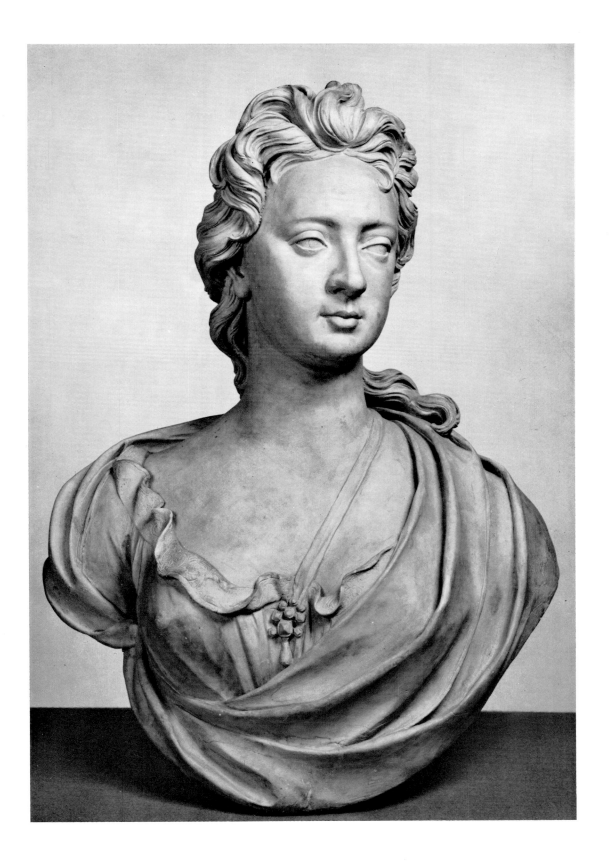

Thomas ADY or ADYE
working 1730–53

Little is known about this attractive sculptor, who from 1737 to 1744 was 'Scultore' to the Society of Dilettanti. In 1752 he submitted estimates for lamp-stands, carved frames and other furnishings for the Mansion House, and was paid for 'atlases and globes of glass for lights'. He also signed a small number of monuments, most of which have a seated female figure holding a medallion portrait, which is also supported by a cherub. Such monuments are adaptations of designs published by James Gibbs in his *Book of Architecture*, 1728, while the handling suggests that Ady had looked with admiration at the work of Michael Rysbrack. His modelling, however, is less vigorous and his drapery patterns less varied than those of the more accomplished Fleming.

Ady died at some time before 1762, when his widow applied to the Society of Artists for financial assistance.

L. Cust, *History of the Society of Dilettanti*, 1914, pp. 31–3; M. D. Whinney, *Sculpture in Britain, 1530–1830*, 1964, p. 127 and pl. 101B.

No. 18

Thomas ADY or ADYE working 1730–53

JOHN FANE, 7th EARL OF WESTMORELAND (1682–1762) 1742

Bust in marble. H. (including base) 2 ft 8½ in. (82·6 cm.) A.65—1949

Inscribed on right of base: Thoˢ ADY 1742

The sitter, bare-headed and with tight curls, looks to his half-right. He wears classical armour, the breast of which shows a relief of Britannia holding an olive branch and surrounded by trophies. The base, inscribed with his name and with his arms and supporters, is identical in pattern with that of Viscount Cobham by Peter Scheemakers (see No. 15).

John Fane, 7th Earl of Westmoreland, had distinguished himself in Marlborough's campaigns, and had subsequently sat as an M.P. He was created Major-General in the year this bust was made. But he had also considerable interest in the arts, for before he succeeded to the title he had built Mereworth Castle (c. 1722–25) which, designed by Colin Campbell, is perhaps the most complete example of the transformation of Palladio's Villa Rotunda into an English country house, and is slightly earlier than Lord Burlington's version at Chiswick.

There seems no doubt that this bust, like No. 15, was originally in the Temple of Friendship, built by Viscount Cobham at Stowe House, Buckinghamshire. Westmoreland's name, but not that of the artist, is quoted in Vertue's list of 1746,[1] but Ady's signature on the bust is recorded by J. T. Smith in 1820 when it was still in the Temple.[2] Smith is not always a completely reliable source, but in this case he had the information from the Librarian at Stowe, so it is likely to be correct.

In this work Ady shows himself a competent sculptor, who had doubtless learnt much from the example of Rysbrack and Scheemakers. The modelling of the head is firm, though perhaps a trifle insensitive, while the attractive handling of the detail of the armour can be paralleled in a number of relatively modest monuments by the same artist.

[1] Vertue, vol. III, p. 133. [2] J. T. Smith, *Nollekens and his Times*, ed. Whitten, vol. II, 1920, p. 48.

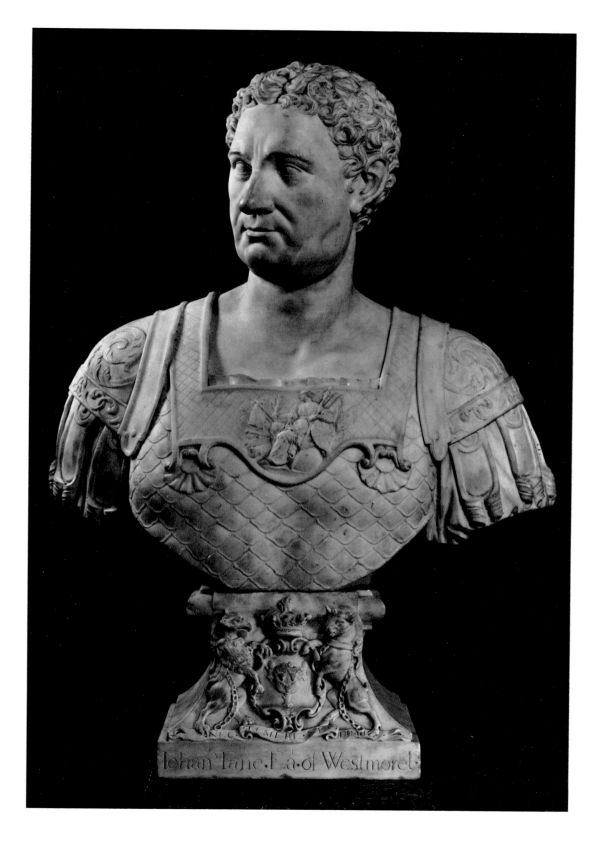

No. 19

Thomas ADY or ADYE
working 1730-53
(Attributed to)

PAUL JODDRELL (?)
(1713-51)
About 1740

Bust in marble.
H. (including base)
2 ft 9¼ in. (84·5 cm.)
A.1—1957
Purchased under the
Bequest of Francis
Reubell Bryan

The sitter, bare-headed and with tight curls, looks to his half-left. Loose classical drapery covers his shoulders and is held on his right shoulder by a circular clasp. There is no inscription but the base bears the arms of Joddrell.

On style the bust must date from about 1740, and the attribution to Ady rests on the similarity of the curled hair and the somewhat rigid setting of the neck with his signed bust of the Earl of Westmoreland (No. 18). Moreover, the treatment of the drapery, particularly the way in which one loop is tucked over another on the left, resembles his work in his signed monument to William Mitchell (1745) at Fowlmere, Cambridgeshire.

The only member of the Joddrell family whose dates would seem to fit the bust is Paul Joddrell of Duffield, Derbyshire (1713-51). He was appointed Solicitor-General to Frederick, Prince of Wales, in 1748, and after Frederick's death held the same appointment to his widow and to the young Prince of Wales, afterwards George III.

As in No. 18 it is clear that Ady had learnt much from his Flemish contemporaries. In this case the drapery brooched on the shoulder may well be derived from a Scheemakers pattern, though it is more complex than is usual with the Flemish artist.

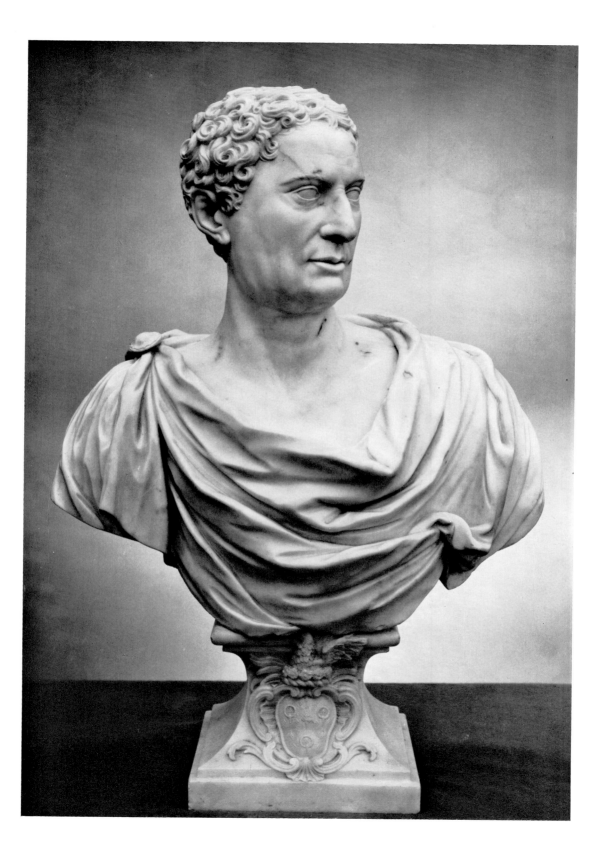

Louis-François ROUBILIAC 1705?–62

Roubiliac was born in Lyons, probably of Huguenot parents. He is said by J. T. Smith (*Nollekens and his Times*, vol. II, 1828, p. 98) to have studied under 'Balthazar of Dresden' (Balthasar Permoser). In 1730, he received the second Grand Prix for Sculpture at the Academy School in Paris, when he was probably a pupil of Nicholas Coustou. He seems to have come to England soon afterwards, marrying here in 1735. He apparently worked first for Thomas or Benjamin Carter, and then for Sir Henry Cheere.

He emerges as an independent sculptor of busts about 1737, and had a resounding success with his statue of Handel (No. 20) in 1738. Early in the next decade he had a few commissions for tombs outside London, but his reputation was finally established by the Westminster Abbey monument to the Duke of Argyll (No. 23 and Fig. 3), commissioned in 1745 and erected in 1749. In 1752 he made a journey, lasting about four months, to Rome in the company of Thomas Hudson, the painter, when he was greatly impressed by both antique sculpture and the work of Bernini. On his return he remained in England till his death ten years later.

Roubiliac is the chief exponent of the rococo style in England, and reveals his character by his interest in movement. This may be seen in his designs for monuments, where the figures are often shown in rapid motion, but also in many of his busts, where the head is sharply turned. It is carried also into his actual modelling, for he uses small forms which break the surface into small patches of light and shade. An inventive and often highly original artist, he is perhaps at his most impressive as a maker of busts, which are full of character and extremely varied in design. His monuments are not uniformly successful, but the finest of them, with their asymmetrical designs and imaginative conceptions rank very high in the history of English sculpture.

K. A. Esdaile, *Louis François Roubiliac*, 1928; M. D. Whinney, *Sculpture in Britain, 1530–1830*, 1964, pp. 102–15.

No. 20

Louis-François
ROUBILIAC
1705?–62

**GEORGE FREDERICK
HANDEL** (1685–1759)
1738

Statue in marble.
H. 4 ft 5¼ in. (135·3 cm.)
A.3—1965
Purchased with the
assistance of the National
Art-Collections Fund

Signed on the plinth:
**L. F. ROUBILIAC
IN.**[II] **ET. SCUL.**[II]

Handel is seated cross-legged and leaning to his right, playing a lyre. His left elbow rests on a pile of bound scores of his works, titled ALEX FEAST, OPERAS, ORAS and LESSONS. He wears informal contemporary dress, a soft cap, a long shirt open at the neck and buttoned to below the waist, loose breeches, stockings and slippers, one of which has been discarded and lies beneath his right foot. He has also a full loose gown, covering the seat and falling to the ground on either side of his legs. At his feet on his left is seated a putto, who is inscribing the notes Handel plays on paper propped against a viol, while to the left on the base are a flute and an oboe.

This remarkable work was commissioned in 1738 from Roubiliac, then an almost unknown sculptor, by Jonathan Tyers (see No. 22), the owner of Vauxhall Gardens, the popular pleasure gardens on the south side of the Thames.[1] It stood originally in the South Walk in a niche of verdure, under an arch, probably of timber with plaster decorations, but the setting was altered by 1751, the arch was removed, and the figure was free-standing in front of a semi-circle of supper-boxes. It remained at Vauxhall until at least 1813, was for a time in the possession of the descendants of Jonathan Tyers and then, after changing hands, was bought by the Sacred Harmonic Society, when the present pedestal was probably added. Finally, for some eighty years, it was owned by the music publishers, Novello and Company, who sold it to the Museum.

The statue is a landmark in the history of sculpture. Not only was it Roubiliac's first major work, but it was also the first work in Europe to honour a living artist, though figures of royal or military personages were common enough. Moreover, it was highly original in its blend of reality and allegory. Handel, life-like though the figure is, can never have played a lyre and, since this instrument has the sun-burst as the decoration of its head, there is undoubtedly the intention to suggest that Handel also represents Apollo. The decorations at Vauxhall were gay and contemporary rather than allegorical in tone,[2] and the statue was a perfect blend of homage to the great musician, a leading figure of London's artistic life, and to the eternal power of music. Whether the invention was the sculptor's or his patron's is impossible to say, but it should be noted that both belonged to that St Martin's Lane circle, which included Hogarth and the engraver, Hubert Gravelot, who did so much to further the taste for the rococo in England.[3]

For, stylistically, the Handel is a rococo work, indeed, one of the most important to be made in England. This lies, not only in its informal character, but in the wonderfully fluid cutting, in which small forms are used so that the ripple of light over the surface gives

[1] For a full discussion of the work, with plates showing the Gardens, see T. Hodgkinson, 'Handel at Vauxhall', *Victoria and Albert Museum Bulletin*, vol. I, no. 4, 1965, pp. 1–13. This supersedes the earlier account in K. A. Esdaile, *Louis François Roubiliac*, 1928. [2] For a discussion of Francis Hayman's decorations of the supper boxes, some of which are in the Museum, see L. Gowing, *Burl. Mag.*, vol. XCV, 1953, pp. 4–19. [3] M. Girouard, 'English Art and the Rococo', *Country Life*, vol. CXL, 1966, pp. 58, 188, 224.

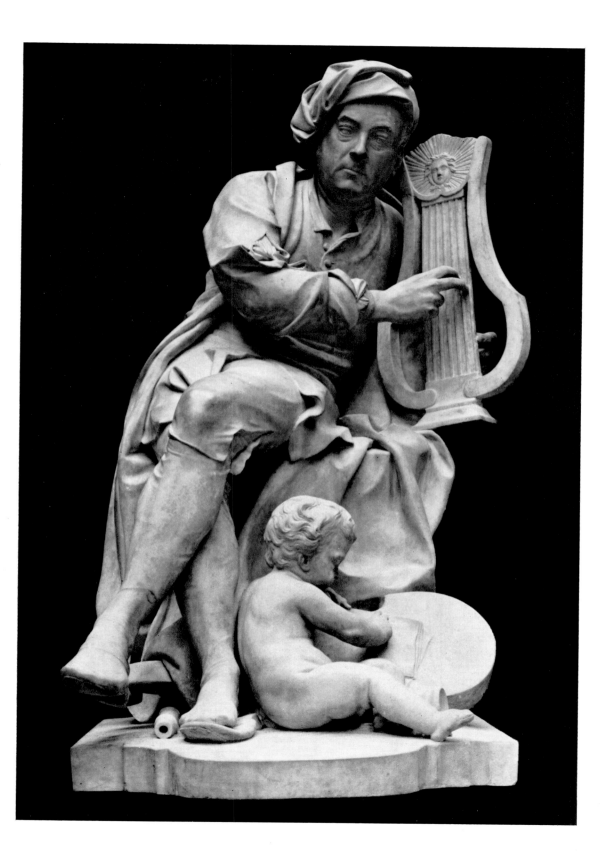

liveliness, but never descends to triviality. It is no wonder that this brilliance, together with the superb ability to create a portrait was to cause a considerable sensation, and to raise Roubiliac to the first rank of sculptors working in England.

No. 21

Louis-François ROUBILIAC 1705 ?–62

ALEXANDER POPE (1688–1744) From a model of about 1738

Bust in marble. H. (including base) 2 ft 0$\frac{11}{16}$ in. (62·7 cm.) A.14—1947 Given by Dr W. L. Hildburgh, F.S.A.

The sitter, without a wig, is turned slightly to his left, his shoulders and breast having simple drapery.

Roubiliac's portraits of Pope, though they present considerable problems,[1] are by common consent among the most sympathetic and penetrating representations of the poet. They are the more remarkable since they fall early in the sculptor's career and show that he had not only already achieved great subtlety in modelling, but had also assimilated the convention of the classicizing bust popularized in England by Rysbrack and Scheemakers, though little used on the Continent at this period.[2]

Although the Museum's bust is undated, it seems to derive together with a number of other busts of Pope, from a terracotta of about 1738 (Barber Institute of Fine Arts, Birmingham). Four dated marble versions are known, all differing slightly (Temple Newsam, Leeds, 1738; Earl Fitzwilliam Coll., 1740; Shipley Art Gallery, Gateshead, 1741; and Earl of Rosebery Coll., 1741).[3] All four are inscribed *ad vivum*, but the features are so close to those of the terracotta that it seems improbable that Pope sat again for each repetition. The Museum's bust seems closest to the Rosebery example of 1741, though the drapery is not identical and is arranged in slightly more complex folds. It is clear that the portrait immediately became popular. Many marble repetitions are known, some of them, including the present example, being certainly contemporary and possibly made in Roubiliac's studio. Some free variants were also created, though these are not easy to date, and plasters were certainly made. A plaster from the original terracotta was bought in Roubiliac's sale by Dr Maty, Librarian of the British Museum, and presented to that Museum with other Roubiliac plasters in 1762.

Apart from the number of copies, the descriptions of the bust show the lasting interest it aroused. George Vertue,[4] writing in 1741, noted that Roubiliac 'had modelled from the Life several busts of portraits

[1] For the most complete discussion, see W. K. Wimsatt, *The Portraits of Alexander Pope*, Yale, 1965, Chapter 9, in which the Museum's bust is catalogued on pp. 250–251. Professor Wimsatt's work on the busts supersedes that of K. A. Esdaile, *Louis François Roubiliac*, 1928, pp. 47–9, 103–05, 185. [2] So far as is known, the only earlier example by Roubiliac of a classicizing bust is the Newton of 1737 (marble, Royal Society; terracotta, Astronomer Royal, Hurstmonceux). [3] The Temple Newsam bust does not show the full width of the shoulders, and the Fitzwilliam bust, undraped, is of the head and neck only. Both the others show shoulders and chest lightly draped. In every case except the Gateshead bust the eyes are incised.
[4] Vertue, vol. III, p. 105.

80

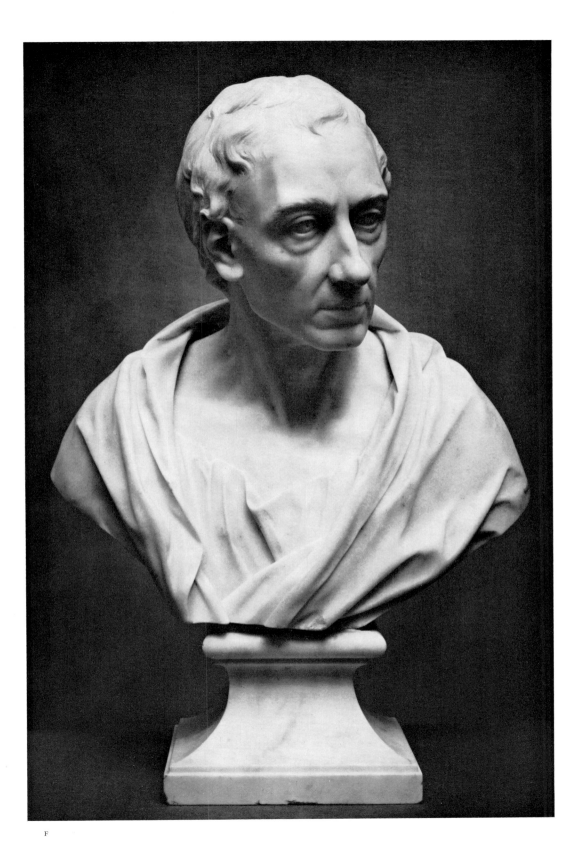

F

extreamly like Mr. Pope, more like than any sculptor has done I think'. John Flaxman, whose father was employed as a modeller by Roubiliac, and who almost certainly made casts for him, remembered late in life that his father saw Pope sitting in an armchair, while Roubiliac worked on the bust.[5] And Sir Joshua Reynolds passed on to Edmond Malone the sculptor's own account of the sitter: 'Roubilliac the statuary, who made a bust of him from life, observed that his countenance was that of a person who had been much afflicted with headache, and that he should have known the fact from the contracted appearance of the skin between his eyebrows, though he had not been otherwise apprised of it'.[6]

Roubiliac had indeed created an unforgettable portrait of a man who had suffered much throughout his life; but he had seen and conveyed that, though Pope may have had a bitter tongue, he had also the endurance and the fine discrimination to become the greatest poet of his age.

[5] Wimsatt, *op. cit.*, p. 229. It is not impossible that some of the existing plasters are the work of the elder Flaxman. [6] J. Prior, *Life of Edmond Malone*, 1860, pp. 428–29.

No. 22

Louis-François
ROUBILIAC
1705?–62

JONATHAN TYERS
(d. 1767)
About 1738

Bust in terracotta
H. (including base)
2 ft 4 in. (71·1 cm.)
A.94—1927

Tyers is shown clean-shaven and full-face, wearing a soft cap. His shirt is open at the neck, and loose drapery covers his shoulders.

Jonathan Tyers contributed much to the life of eighteenth-century London, for in 1728 he leased land at Vauxhall, where in June 1732 he opened the famous Vauxhall Gardens, with a *ridotto al fresco*, providing orchestral concerts, and after 1745 vocal music as well.

He was a friend of Hogarth's, the supper boxes were decorated by Francis Hayman (some parts of these decorations being in the Museum), and he gave Roubiliac his first important commission (see No. 20). A drawing by Thomas Rowlandson showing the gardens rather later in the century is also in the Museum (P.13—1967).

The bust, which appears to have been owned at one time by Tyers' descendants,[1] in all probability dates from the time when he was employing Roubiliac, and therefore forms a group with the busts of Handel (terracotta, Foundling Hospital; marble, Windsor Castle) and Hogarth (terracotta, National Portrait Gallery). It is careful and competent in modelling, a convincing portrait of a shrewd business-man, and a good example of the sculptor's busts in informal dress, though it has not the superb quality of his later work in this manner.

The marble, which is less lively in quality, is in the City Art Gallery, Birmingham.

[1] K. A. Esdaile, *Louis François Roubiliac*, 1928, p. 41.

82

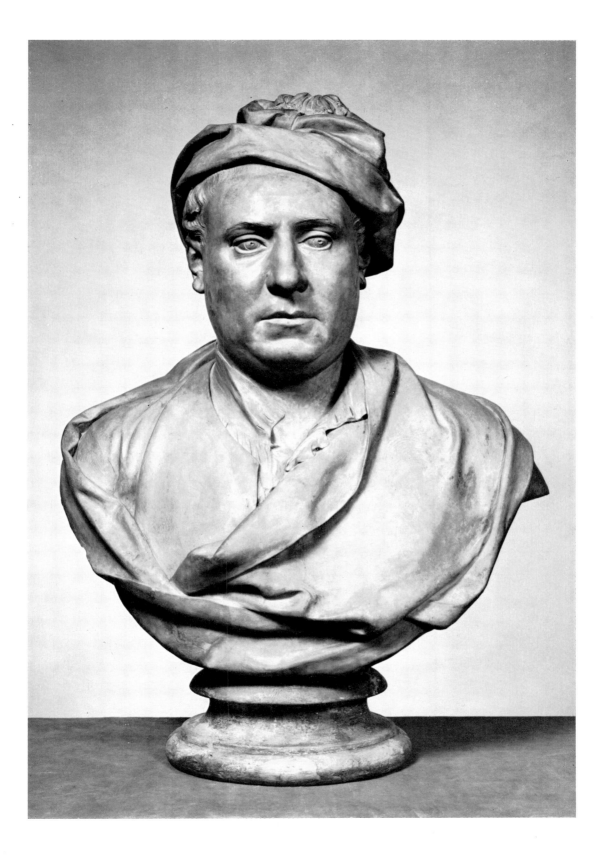

No. 23

Louis-François ROUBILIAC
1705?–62

Model for a monument to John, 2nd Duke of Argyll and Greenwich (1680–1743), in Westminster Abbey 1745

Terracotta.
H. 2 ft 11¼ in. (89·5 cm.).
W. 1 ft 7¾ in. (50·2 cm.)
21—1888

Inscribed on the base below the figure of Eloquence: L. F. Roubiliac in^t et Fecit 1745

The Duke, wearing classical armour, reclines on a sarcophagus, his left arm resting on the knee of the Muse of History, who stands leaning forward on the right. In her left hand she holds a book, resting on a cannon ball, and inscribed: NATUS DIE 10 mensis 8. MDCLXXX OBIIT DIE 3 mensis 8. MDCCXLIII. With her right hand she writes on a pyramid, which forms the background of the monument. Part of a cannon is visible at its base beyond the Duke's feet. The base of the sarcophagus is adorned with sword, baton, coronet and Garter.

Below the sarcophagus is a relief of Liberty seated between two columns, with a putto holding a scroll at her feet, while two further putti present her with a sword and shield. Flanking the relief on projecting bases slanting forwards are (left) Eloquence standing with her right arm extended and a caduceus, the lower part missing, in her left, and (right) Pallas, armed beneath her cloak and looking upwards. She has a shield on her knee supported by her right arm, and may originally have held a lance in her left hand as in the monument and in a drawing in the Museum.[1] Her shield bears a medallion portrait, inscribed: CN POMPEVS, while behind Eloquence is another medallion portrait inscribed DEMOSTHENES, (ΔHMOϽΘENHϽ) in Greek capitals with the sigmas reversed.[2]

John, Duke of Argyll, after a somewhat chequered and unstable political career, in which he was much given to intrigue, first attained real distinction when his military experience, gained originally under Marlborough in Flanders, led him to play a leading part in the attempt of the Old Pretender to regain the throne in 1715. He was also a notable orator, achieving great popularity in Scotland by his defence before Parliament of the city of Edinburgh at the time of the Porteous Riots. Sir Walter Scott was to draw an unforgettable portrait of him in *The Heart of Midlothian*, but he was not without honour among his own contemporaries, for Pope spoke of him as 'destined to shake alike the Senate & the Field', and James Thomson in *Autumn*, 1730, records:

> 'Powerful as thy sword, from thy rich tongue
> Persuasion flows, & wins the high debate.'

It is easy to see why Eloquence and Pallas were regarded as appropriate figures for his monument.

The monument itself (Fig. 3), which stands in the South Transept of Westminster Abbey, was completed in 1749. As will be seen, a number of small changes were made, the most important from the point of view of the design being the alteration in the poses of the Duke and the figure of History. In the marble he rests his head on his left arm, and the left leg of History is no longer covered, and so aids greatly the swiftness of her movement towards the left, making the play of diagonals in the upper part far more forceful.

[1] Physick, p. 120, fig. 83. [2] K. A. Esdaile, *Louis François Roubiliac*, 1928, pp. 61–6, gives a full account of the commission, with many references.

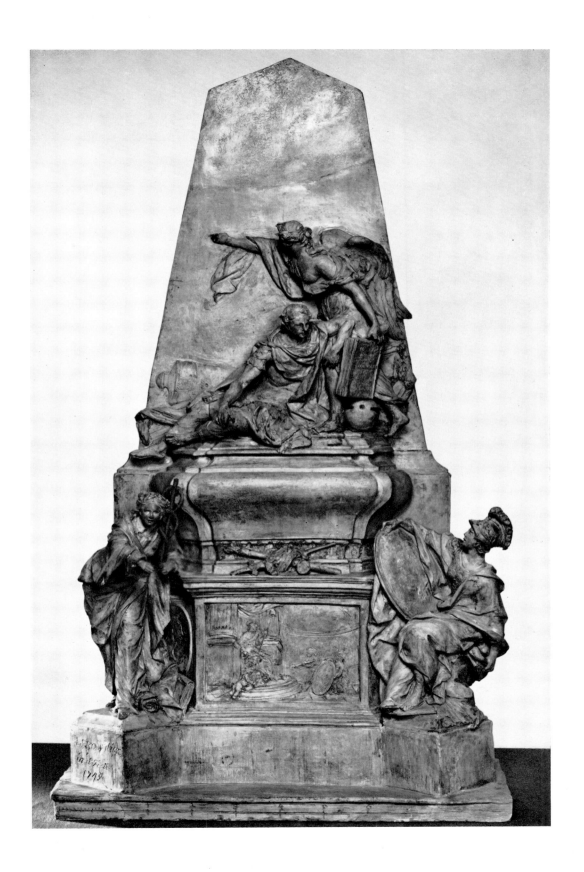

Inevitably the monument caused a great sensation: George Vertue[3] records his impression of it at great length, for he considered it to 'outshine for nobleness & skill all those before done, by the best sculptors, this fifty years passed', and he was enchanted by the surface cutting 'the Draperys and foldings truely natural and excels all others in skill & surface of plaits really more like Silk than Marble'.

The figure of Eloquence received the greatest praise. Horace Walpole, who did not much care for Roubiliac's work, described it as 'very masterly and graceful',[4] other English sculptors are said to have greatly admired it, and Canova, an artist with very different standards, spent much time looking at it during his visit in 1815, for he thought it one of the finest statues he had seen in England.

The sculptor is said to have lost £300 besides his labour on the monument, presumably his original estimate of £1200 (and he received £200 in addition) had much underrated the cost of the materials, but perhaps even more than the statue of Handel, made some ten years earlier, it established his reputation and led to other important commissions for monuments. A number of these are still to be seen in Westminster Abbey, but none is more brilliant in execution or more original in design than the *Argyll*.

[3] Vertue, vol. III, pp. 146, 148–49. [4] Horace Walpole, *Anecdotes of Painting*, vol. IV, 1782, p. 213.

No. 24

Louis-François ROUBILIAC 1705?–62

PHILIP DORMER STANHOPE, 4th EARL OF CHESTERFIELD (1694–1773) About 1745

Bust in bronze.
H. (including marble base) 1 ft 11 in. (58·4 cm.).
H. (excluding marble base) 1 ft 5¾ in. (45·1 cm.)
A.17—1959

The sitter, bare-headed, looks to his half-left, and only the neck and part of the shoulders, undraped, are shown. The bust is not signed, but is authenticated by a plaster, bought by Dr Maty at Roubiliac's Sale in 1762 and presented to the British Museum.[1] This is both higher and wider than the bronze, the whole chest and shoulders being included, but the head is identical.[2]

The portrait, which is vigorously modelled, with the eyes deeply incised, has the distinction of bearing which might be expected in the famous writer of the *Letters to his Son*. It may well have been his own wish that he was portrayed in the classical manner and not in contemporary dress, for in the letter to his son of 17 May 1745, he speaks with admiration of the bust of Cicero he has just added to his library, and in his constant advice to his son about education and deportment there are many references to the importance of Antiquity as a guide.

[1] K. A. Esdaile *Louis François Roubiliac*, 1928, p. 103, and pl. XXIII. [2] Although no bronze appeared in Roubiliac's Sale, two terracottas and three plasters of Lord Chesterfield were included. Except for the British Museum example, the present whereabouts of these is unknown.

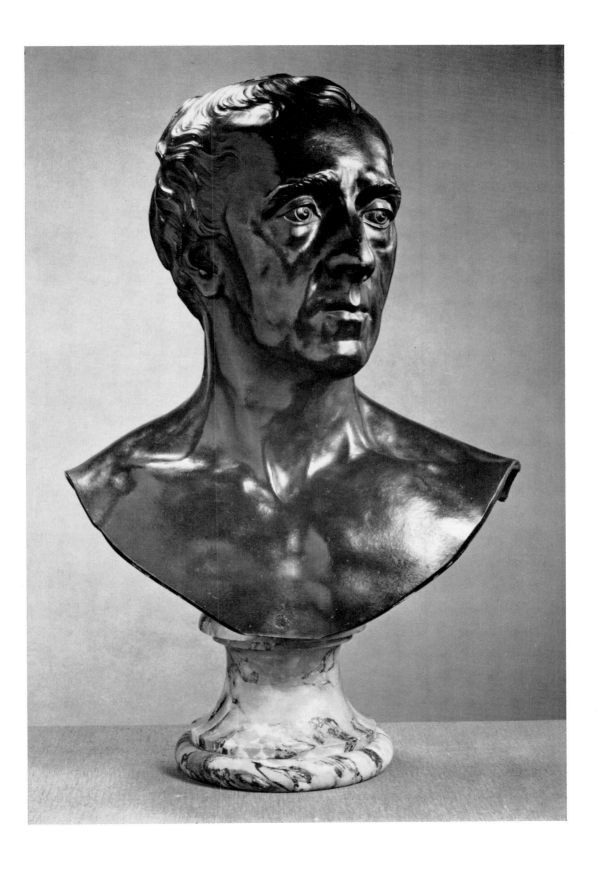

The bust must inevitably be compared with the fine marble of 1757 by Joseph Wilton in the British Museum.[3] The sitter was older, perhaps more easy-going and more genial, and the modelling is much softer, but it lacks the enormous aristocratic distinction of Roubiliac's bust, which reflects so well the writer of the *Letters.*

[3] M. D. Whinney, *Sculpture in Britain, 1530–1830,* 1964, p. 138 and pl. 108A. Mrs Esdaile mistakenly regarded the Wilton as an imitation of the Roubiliac.

No. 25

Louis–François ROUBILIAC
1705 ?–62
(Attributed to)

DR SALMON (d. 1773)
About 1750

Bust in lead on marble base.
H. (including base)
2 ft 3⅞ in. (70·8 cm.).
H. (excluding base)
2 ft 0⅞ in. (63·2 cm.)
A.19—1921

The sitter, wearing a turban-like hat with a tassel, looks to his half-left. His pleated shirt, open at the neck and worn under an embroidered coat, is visible under his cloak.

This bust and No. 26 were sold to the Museum by a vendor who had inherited them from a relative by marriage, who was himself a member of the Salmon family. They were traditionally the portraits of W. H. Salmon, called 'Doctor' of Holcombe, Somerset, and his wife.

The liveliness of modelling, and the competence in the design of the bust supports Mrs K. A. Esdaile's[1] attribution to Roubiliac, who is known on occasions to have worked in lead. The other contemporary sculptors who most favoured this material were Sir Henry Cheere and his brother John, but these busts seem too sensitive to be their work.

[1] K. A. Esdaile, *Louis François Roubiliac,* 1928, p. 93.

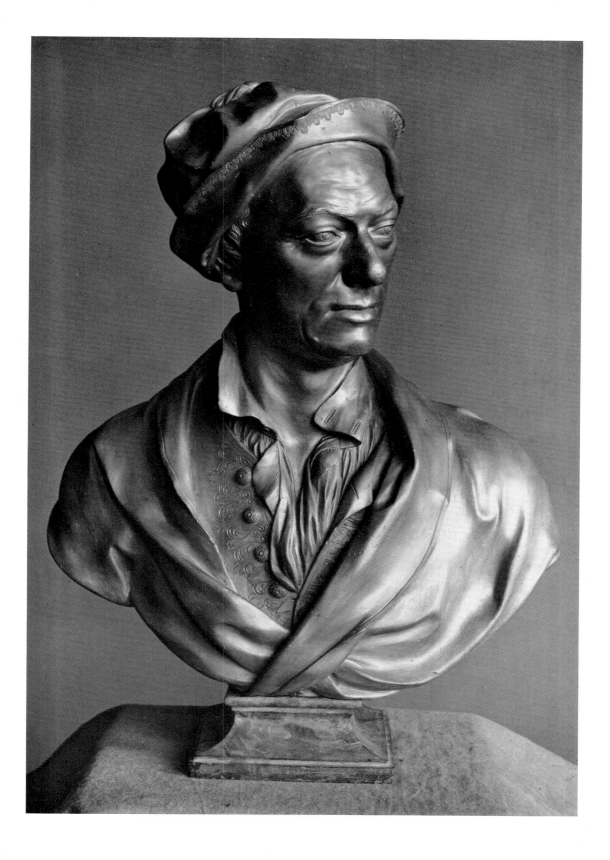

No. 26

Louis-François
ROUBILIAC
1705 ?–62
(Attributed to)

MARY SALMON
About 1750

Bust in lead with marble base.
H. (including base)
2 ft 1 in. (63·5 cm.).
H. (excluding base)
1 ft 10 in. (55·9 cm.)
A.20—1921

The sitter, who was the wife of Dr Salmon (No. 25), looks to her half-right. The lace edge of her dress is visible under a cloak or shawl knotted at the breast.

This bust has the same history as No. 25, and its delicacy of surface again supports the attribution to Roubiliac.[1] His female busts are few in number and the drapery tends to be more complicated, but the treatment of the hair, though simpler, is not unlike that of his *Princess Amelia* (Fitzwilliam Museum, Cambridge), and the softness of modelling appears superior to known busts by Sir Henry Cheere.

[1] K. A. Esdaile, *Louis François Roubiliac*, 1928, p. 93.

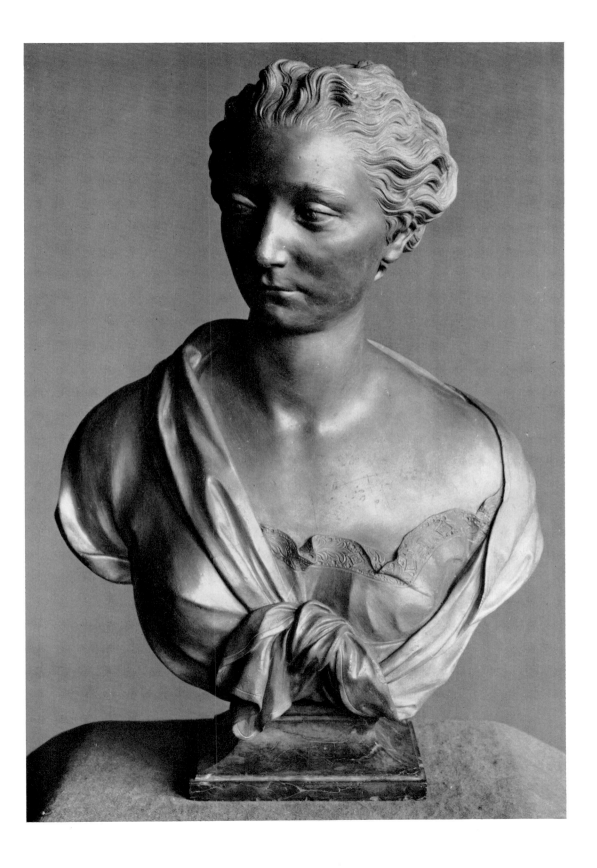

No. 27

Louis-François
ROUBILIAC
1705?–62

Model for a monument
to John, 2nd Duke of
Montagu (1688–1749), in
Warkton Church,
Northants.
About 1750

Terracotta.
H. 1 ft 1$\frac{11}{16}$ in. (34·8 cm.).
W. 1 ft 0$\frac{1}{2}$ in. (31·8 cm.)
A.6—1947
Given by Dr W. L.
Hildburgh, F.S.A.

The model, which appears to be a first sketch, shows Charity with a child in her arms and another standing in front of her, hanging a medallion portrait of the Duke on a complex architectural construction, the central portion of which has a rounded top, surmounted by an urn in front of a smaller, roughly sketched piece of architecture. A boy leans down in front of the urn to assist in the hanging of the portrait, and at the sides of the main panel are extensions adorned with trophies. The whole rests on a high podium, to the left of which stands the widowed Duchess, looking up, and holding a cartouche.[1]

John, 2nd Duke of Montagu, who had married Mary, the youngest daughter of the great Duke of Marlborough, was Master General of the Ordnance from 1740 to 1741, and again from 1743 till his death. He was clearly a humane man, and the figure of Charity was selected with good reason. The Duchess, however, was not responsible for the iconography of the monument, as she placed £1,000 for the cost and the entire control in the hands of Dr Martin Folkes, President of the Society of Antiquaries and also of the Royal Society, whose bust by Roubiliac (1749; Wilton House) is further proof that the scholar and the sculptor were in close touch at this time.

Another model for this monument and one for Roubiliac's monument to the Duchess, who died in 1751, belong to the Dean and Chapter, Westminster Abbey. This second model for the Duke's monument is clearly later than that belonging to the Museum, for it is more finished in technique, and closer to the marble at Warkton (Fig. 4). The differences between the Museum model and the marble are partly of proportion, but the architecture, though less decorated, is far more rococo in detail, the poses of all the figures are slightly changed and clarified, and the Duchess holds a chaplet of flowers instead of a cartouche.[2]

Although this monument lacks, perhaps, the supreme charm of the companion one of the Duchess, which shows the Three Fates in rococo costume, it is, nevertheless, one of the sculptor's finer examples of the asymmetrical monument, which was then such a novelty in England, and it is sad that its position in the village church makes it hard to see or to photograph adequately.

Its date is beyond question, for Andrea Soldi's portrait of Roubiliac in the Dulwich Art Gallery, dated 1751, shows him at work on the group of Charity. The design was therefore indubitably fixed before the sculptor's journey to Rome in the autumn of 1752, but whether the marble had been erected by then is uncertain.[3]

[1] K. A. Esdaile, *Louis François Roubiliac*, 1928, pp. 66–7, quotes a contemporary reference which refers to the second female figure as Fame, and not as the Duchess. This presumably refers to an earlier project for five designs and one 'mould in plaister' were in Roubiliac's Sale of 1762 (*ibid.*, pp. 223, 226).　　[2] T. Hodgkinson, 'A Sketch in terracotta by Roubiliac', *Burl. Mag*, vol. LXXXIX, 1947, p. 258.
[3] Mrs Esdaile, *op. cit.*, p. 67 appears to be wrong in finding a resemblance between the Charity and that by Bernini on the tomb of Alexander VII (1671–78: St Peter's, Rome), since the pose and handling are quite different.

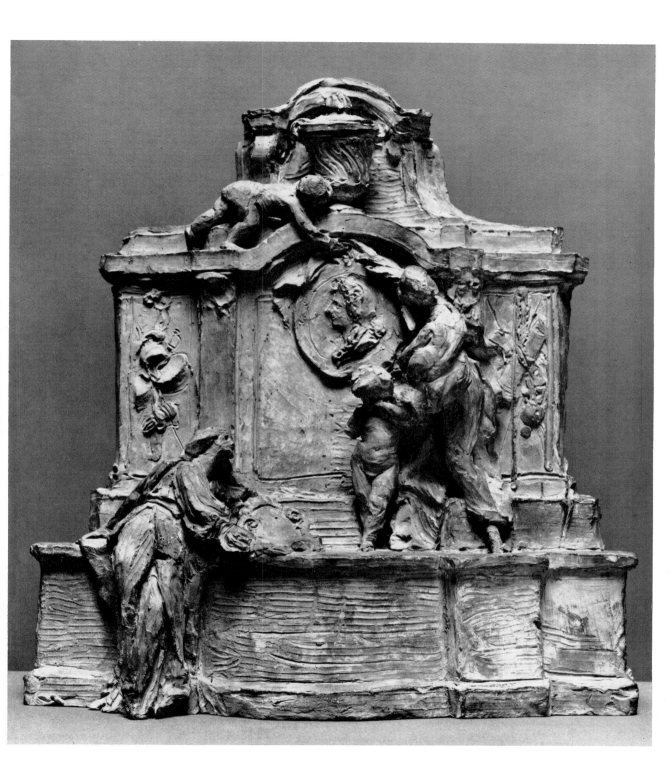

No. 28

ANONYMOUS

WILLIAM AUGUSTUS, DUKE OF CUMBERLAND
(1721–65)
Probably 1746

Bust in lead, covered with bronze paint, on a marble base.
H. (including base) 2 ft 2 in. (66 cm.).
H. (excluding base) 1 ft 10⅝ in. (57·5 cm.)
A.12—1947

The sitter, with his hair curled over his ears and tied at the nape of the neck, looks slightly to his left. He wears military uniform, a gorget with the arms of Hanover and aiguillettes, with the sash of the Garter and the star on the left of his tunic; another sash falls across his chest from his right shoulder outside the tunic. The marble base is inscribed: REPVBLICA SERVATA MDCCXLVI

The inscription on the base records Cumberland's victory over the Young Pretender at Culloden, when the rebellion of 1745 was broken. A number of medals in his honour were struck in 1746, some of which seem to show him as a younger man. He was twenty-five at the time, and though the bust could be of an older man and therefore made later as a commemorative piece, the contemporary medals and some portraits already show the heavy jowl and retreating hair which appear in the bust. Moreover, it is improbable that a later bust would have this inscription.

The portrait is a lively one, and the modelling is by no means incompetent. Though it has some affinity to works by John Cheere, it would be rash to suggest that he was the sculptor.

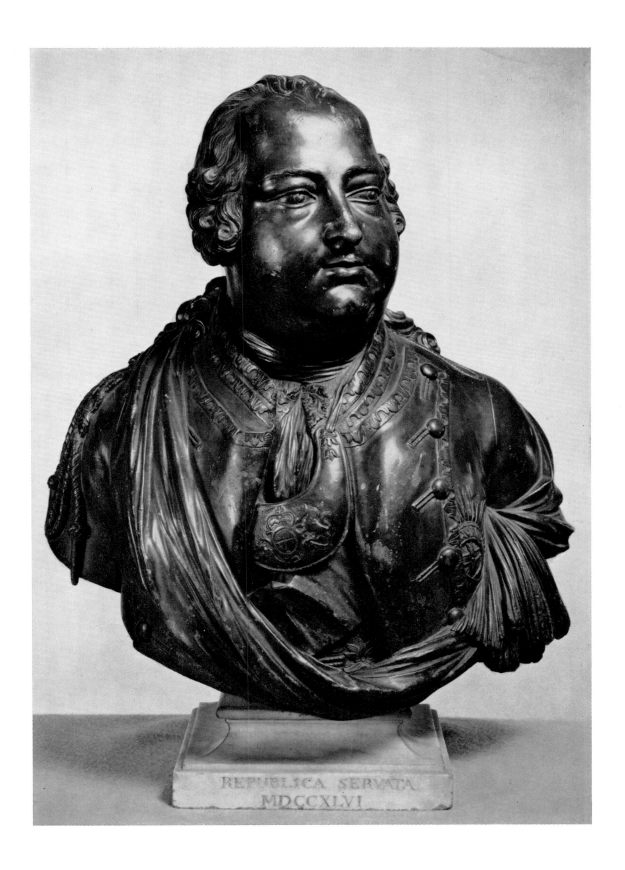

REPUBLICA SERVATA
MDCCXLVI

Joseph WILTON 1722–1803

Wilton had an exceptionally good training for an English sculptor. His father, a maker of papier-mâché ornaments, sent him when still quite young to study under Laurent Delvaux (q.v.) at Nivelles and he afterwards went to Paris to the studio of Jean-Baptiste Pigalle. It may well be that the hesitation between the baroque and the more strictly classical styles, which can be seen in some of his work, is due to the diverse character of this training. In 1747 he went to Italy, remaining there for seven years, first in Rome and then in Florence. The busts of Dr Cocchi (No. 29) and of Lord Chesterfield (British Museum) reveal the attention he had paid to antique sculpture. On his return he began to build up a considerable practice for both monuments and busts, his most famous work being the monument to General Wolfe in Westminster Abbey (designed in the 1760s, erected 1772), in which Wolfe is shown nude, though the other figures and their setting recall the more pictorial manner of Roubiliac. He was one of the Founder Members of the Royal Academy in 1768, and exhibited there from 1769 until 1783. By then his practice was declining; he lived beyond his means and by 1793 was declared a bankrupt. In 1790 he was appointed Keeper of the Royal Academy, and held that post until his death. The busts in the Museum show that he was a sculptor of very considerable talents. Had all his later work reached the same standard, he would have been the outstanding English sculptor of the eighteenth century.

No. 29

Joseph WILTON
1722–1803

DR ANTONIO
COCCHI (1695–1758)
1755

Bust in marble.
H. (including base)
2 ft 10½ in. (61·3 cm.)
A.9—1966
Purchased under the
Bequest of M. L. Horn

Inscribed on the back:
I Wilton sct.

The bald sitter looks slightly to his right, his shoulders and breast being without drapery. On a medallion on the shaped base is inscribed: ΑΝΤ. ΚΟΚΧΙΟΣ ΞΑΨΝΕ ΓΗΡΑΣΚΩ ΔΙΔΑΣΚΟΜΕΝΟΣ, giving a Greek rendering of the sitter's name, his age as 60, the date 1755 and the statement 'I go on learning, as I grow old'. The medallion is encircled by a serpent biting its tail, which may stand for Infinity, or according to Cesare Ripa's *Iconologia* may symbolize Perseverance. The serpent is also an attribute of Medicine.

The bust was made during Wilton's last year in Italy, and portrays a celebrated physician and scholar, who was an intimate friend of Horace Mann, the British envoy in Florence.[1] It is one of his most distinguished works, lively, sensitive and extremely realistic in modelling, while its undraped form, without parallel in its day in Europe, is evidence of Wilton's study of antique busts.

Fifteen years later, a bronze version was placed by a pupil of Cocchi's on his monument in the church of Santa Croce, Florence.

[1] T. Hodgkinson, 'Joseph Wilton and Doctor Cocchi', *Victoria and Albert Museum Bulletin*, vol. III, no. 2, April, 1967, pp. 73–80, gives a full account of Cocchi's career.

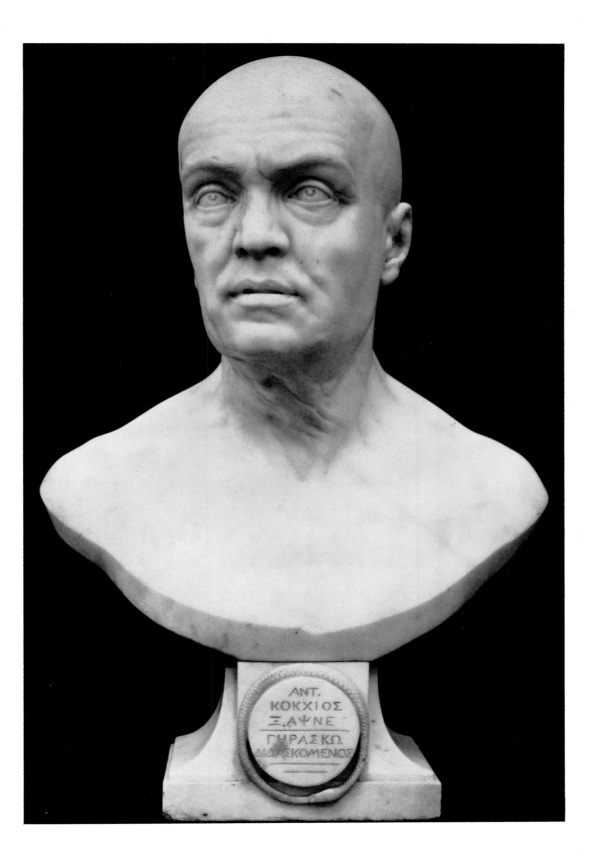

No. 30

Joseph WILTON
1722–1803

OLIVER CROMWELL
(1599–1658)
1762

Bust in marble.
H. (including base)
2 ft 5½ in. (74·9 cm.).
H. (excluding base)
1 ft 11⅞ in. (60·6 cm.)
A.32—1930

Inscribed on the base:
Opus Josephi Wilton 1762

Cromwell is shown turning slightly to his right and wearing a cuirass, with a knotted and flowing cravat. His hair, which is receding, falls in curls on to his shoulders.

Wilton is recorded as having made and exhibited at The Society of Artists at least two marble busts of Cromwell, one in 1761, and the other in 1766.[1] The latter is probably the Museum's bust. It is described as being 'from the noted cast of his face, preserved in the Great Duke's Gallery at Florence'.[2] This cast, which Wilton might well have seen, is of tinted plaster with glass eyes, and is now in the Bargello. It is thought to be a version of the funeral effigy of Cromwell. It has, however, no moustache (this might originally have been added in real hair), so that Wilton must also have borrowed from some other likeness of Cromwell, possibly one of the painted portraits, or a bust such as that by Edward Pierce (signed and dated 1672) now in the London Museum.

Whatever his sources may have been, Wilton has created a lively and convincing portrait. It was clearly much liked, for a number of other versions are known. For the terracotta model, see No. 31.

[1] A. Graves, *The Society of Artists of Great Britain, 1760–1791*, 1907, p. 283, no. 168 and p. 284, no. 221. [2] D. Piper, 'The Contemporary Portraits of Oliver Cromwell', *Walpole Society*, vol. XXXIV, 1952–54, p. 41 and pl. XIII.

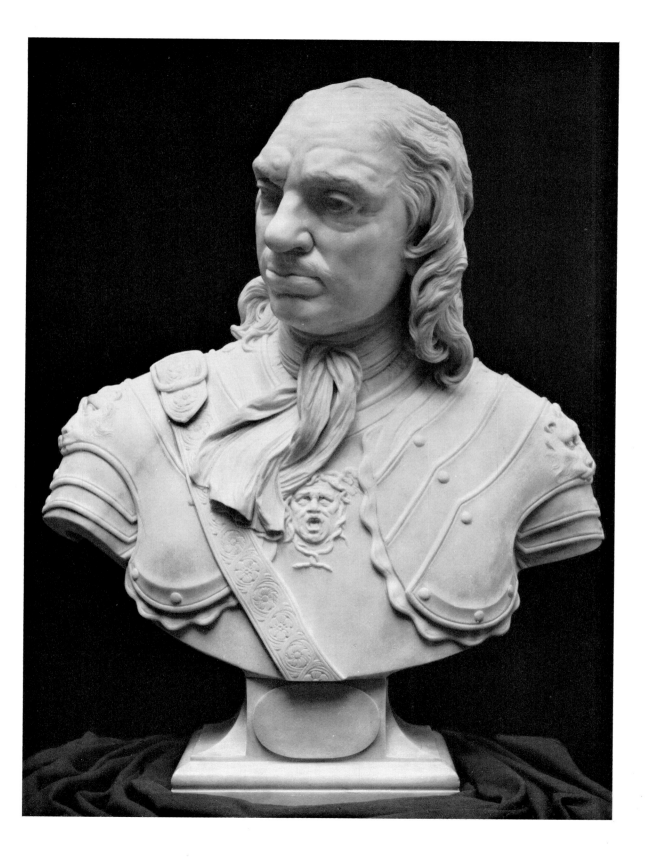

No. 31

Joseph WILTON
1722–1803

OLIVER CROMWELL
(1599–1658)
1762

Bust in terracotta.
H. (including base)
2 ft 4 in. (71·1 cm.).
H. (excluding base)
1 ft 10¾ in. (57·8 cm.)
A.72—1965
Bequeathed by Rupert
Gunnis

This is the terracotta model for No. 30, the position and details being identical. A comparison of the two, however, shows that the terracotta is far more sensitive in modelling, and that much has been lost in the marble, though the latter is a good example of Wilton's work. But in the terracotta the passages round the eyes and the vein in the left temple show exceptional liveliness, and an ability which almost equals that of Roubiliac to create a portrait of a man long dead.

The soft scarf round the neck would never have been worn in Cromwell's day, but its treatment with small folds which repeat each other is characteristic of Wilton's style, and appears in several of his monuments.

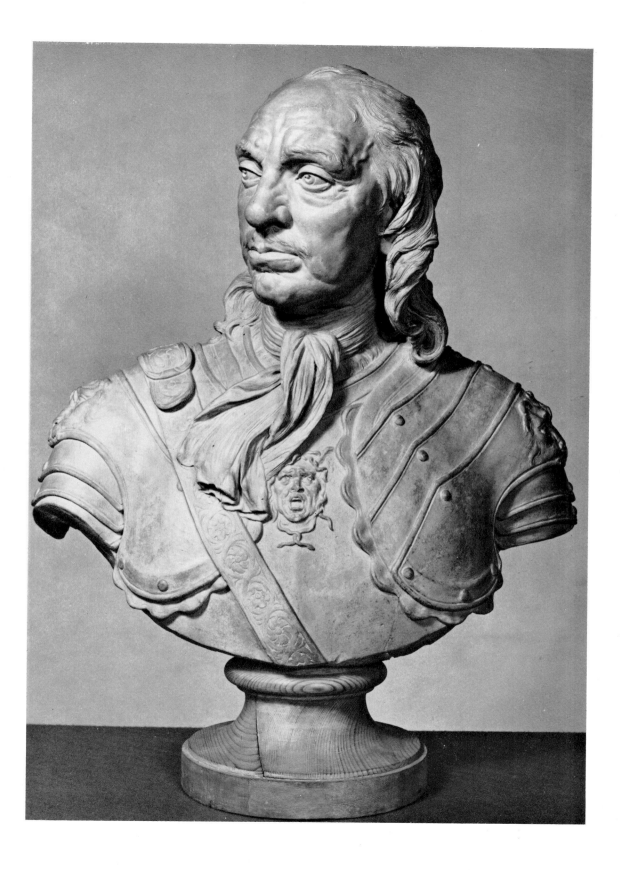

Nathaniel SMITH c. 1741–after 1800

Smith was apprenticed to Roubiliac, and between 1758 and 1762 won six premiums at the Society of Arts. He did not, however, build up a good practice of his own, but after Roubiliac's death in 1762 became the assistant of Joseph Wilton, carving the figures on the Wolfe Monument in Westminster Abbey, and according to his son J. T. Smith, the biographer of Nollekens, he executed most of the work for which Wilton was paid at Somerset House. In about 1788 he became the chief assistant to Joseph Nollekens. Almost his whole life, therefore, was spent in working for other sculptors, and only one signed monument, to Sir Merrick Burrell, 1787, at West Grinstead, Sussex, appears to be his independent work.

J. T. Smith, *Nollekens and His Times*, ed. Whitton, 1920, vol. I, pp. 5, 7, 97; II, pp. 110, 134, 150, 166.

No. 32

Nathaniel SMITH
c. 1741—after 1800

WILLIAM BECKFORD
(1705–1770)
1770

Statuette in terracotta.
H. 10¾ in. (27·3 cm.)
A.48—1928
Given by Dr W. L.
Hildburgh, F.S.A.

Inscribed on the base:
Nath. Smith fecit.
July 31, 1770

Beckford, wearing his robes as Lord Mayor of London over contemporary dress, stands with his left foot advanced. His right hand is raised, and he appears to be speaking. His left hand rests on a pedestal and holds a scroll inscribed: The humble Address.

The work was one of the unsuccessful models[1] in a competition, won by John Francis Moore, for a monument in the Guildhall to William Beckford, the father of the author of *Vathek*, and Lord Mayor in 1763 and 1770. 'The humble Address' was presented to George III in 1770, in connection with John Wilkes and the Middlesex election. There is a drawing for the proposed statue in the Department of Prints and Drawings.[2]

Smith had been apprenticed to Roubiliac, and later worked for Wilton, but the not unsuccessful attempt to give liveliness to the figure seems to be derived from the example of his first master.

[1] J. T. Smith, *Nollekens and his Times*, ed. Whitton, vol. II, 1920, p. 134.
[2] Physick, p. 140, fig. 104.

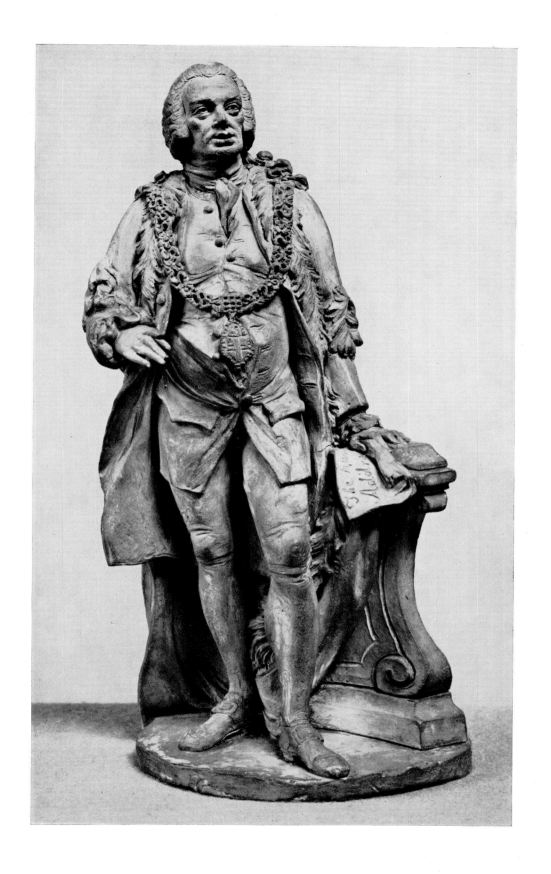

Christopher HEWETSON c. 1739–98

Hewetson was born in Kilkenny, and is said to have studied in Dublin before going to Rome. He is recorded as being in Rome in 1765, and appears to have remained there till his death in 1798.

In Rome he was acquainted with Gavin Hamilton and Thomas Jenkins, both of whom supplied antiques to English collectors, and was evidently in touch with a number of English travellers, for whom he supplied a few very competent busts. He also made two busts of the painter Anton Rafael Mengs (1779, Institut de France; 1781, Protomoteca Capitolina, Rome). He was able to achieve a distinguished likeness, whether in the naturalistic style of *Pope Clement XIV* (No. 33), or in a more austere classical manner, such as the bust of Gavin Hamilton (1784, University of Glasgow).

T. Hodgkinson, 'Christopher Hewetson, An Irish Sculptor in Rome', *Walpole Society*, vol. XXXIV, 1952–54, pp. 42–54.

No. 33

**Christopher
HEWETSON
c. 1739–98**

**POPE CLEMENT XIV
(d. 1774)
1773**

Bust in marble.
H. (including base)
2 ft 6 in. (76·2 cm.)
A.22—1948

Inscribed on the back:
CLEMENS · XIV ·
PONT. MAX. and on
left: Christoᶠ Hewetson
Fecᵗ Romae 1773

The Pope, wearing a skull-cap and a cape tied in front with a knotted cord (broken on the right), is shown looking slightly to his right.

The bust came from the Talbot Collection at Margam Castle, Glamorgan, the sculptor perhaps being introduced to the owner, Thomas Mansell Talbot, by Gavin Hamilton; for Hamilton supplied ancient marbles to Talbot and had been sculpted by Hewetson.[1]

Pope Clement XIV (Ganganelli) was notable for his suppression of the Jesuits, and also for important developments in the Vatican Museum. He planned, but did not live to carry out, a great extension of the galleries, and acquired a good deal of antique sculpture through Gavin Hamilton and Thomas Jenkins. His tomb in SS. Apostoli, Rome, completed in 1787, is by Canova.

Versions of the bust, dated 1772, are at Ammerdown, Somerset, and Gorhambury, Herts. A further version was at Beningbrough Hall, York, in 1927, but its present whereabouts is unknown.

[1] T. Hodgkinson, 'Christopher Hewetson, an Irish sculptor in Rome', *Walpole Society*, vol. XXXIV, 1952–54, p. 43.

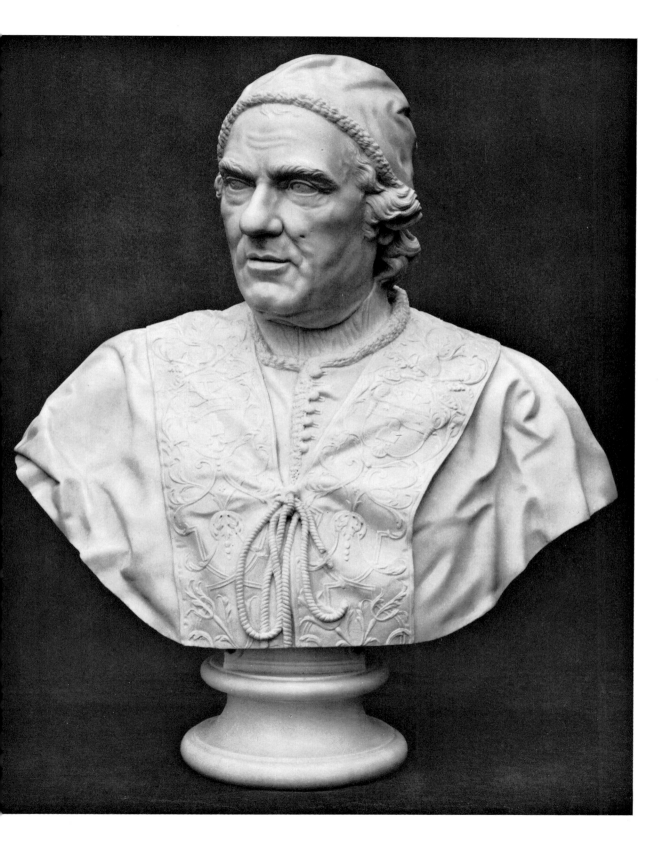

Joseph NOLLEKENS 1737–1823

Nollekens was the son of a conversation painter of the same name working in London, though the family originally came from Antwerp. He was apprenticed in 1750 to Peter Scheemakers, and by the end of the decade had won three prizes at the Society of Arts. In 1760 he went to Rome, where he was to remain for ten years. While there he restored and copied antiques and sold them to the English market, and also made a few fine busts. On his return he quickly built up a large practice, chiefly as a maker of busts and monuments, though he himself preferred his allegorical figures. He was made an Associate of the Royal Academy in 1771 and a full Academician in the next year.

His reputation has been coloured by the biography of his pupil, J. T. Smith, which is among the most spiteful in the English language. The many references to him in the *Farington Diaries* (both in the published and unpublished sections) do not, however, suggest that he was merely a grotesque miser, but imply that he was a sculptor of high reputation, whose opinion was valued by younger men. For a sympathetic portrait of him in old age, see No. 51. Flaxman, indeed, spoke of him as the only sculptor before Banks who had 'formed his taste on the antique and introduced a purer style of art'. In certain respects this is true, but Nollekens was never a whole-hearted follower of neoclassicism, for he admired the works both of Duquesnoy and of Michelangelo, and some of his monuments have a prettiness which still hints at the rococo. His greatest strength was as a maker of busts, for they are full of invention, and almost always very distinguished portraits. Though the great majority of them use classical rather than contemporary dress, the designs are infinitely varied, he took great pains with the first models, and though the marbles were made by assistants, he liked another sitting so that he could execute the final stage himself from the life.

J. T. Smith, *Nollekens and his Times*, 2 vols., ed. Whitton, 1920; J. Flaxman, 'Address on the Death of Thomas Banks', printed in *Lectures on Sculpture*, 2nd ed., 1838, pp. 271–94; M. D. Whinney, *Sculpture in Britain, 1530–1830*, 1964, pp. 157–64.

H

No. 34

Joseph NOLLEKENS
1737–1823

CASTOR AND POLLUX
1767

Group in marble.
H. 5 ft 3¾ in. (160·7 cm.)
A.59—1940
Bequeathed by Mrs H. Borradaile

Inscribed on the base:
JOSEPH NOLLEKENS.
FAC, ROMAE, AN,
D.MDCCLXVII.

The group consists of two nude figures of young men. The one on the right holds in his right hand a torch reversed, with the flame touching a small altar in the foreground, decorated with swags and bucrania; in his raised left hand he holds a second torch backwards over his shoulder. The second youth leans with his left arm round the shoulder of the torch-bearer, and looks down at a flat disc in his right hand. Both figures wear laurel wreaths. Behind the torch-bearer to the right is a small draped female figure standing on an altar.

The work, made by Nollekens in Rome for Lord Anson for Shugborough Hall, Staffs, and sold from Shugborough in 1842, is a copy of an antique group formerly in the collection of Queen Christina of Sweden, and now in the Prado.[1] It had gone to Spain in the seventeenth century, but casts existed, one being recorded in the French Academy in Rome in 1758,[2] which is a possible source for Nollekens's work. It was also copied, with variations, by Coysevox for Versailles.[3]

The group is a typical example of the taste of English eighteenth-century collectors for the Antique. During the ten years (1760–70) which Nollekens spent in Rome, he was in close touch with the dealer, Thomas Jenkins, for whom he restored mutilated antiques, which were then sold as genuine to English travellers. This group, however, is a straightforward copy, and shows the sculptor's competence to follow the antique manner.

[1] For the history of the group, see A. Blanco, *Museo del Prado, Catálogo de la Escultura*, 1957, no. 28. [2] Montaiglon, *Correspondance*, vol. XI, 1901, p. 226.
[3] G. Keller-Dorian, *Antoine Coysevox*, 1920, vol. II, no. 89.

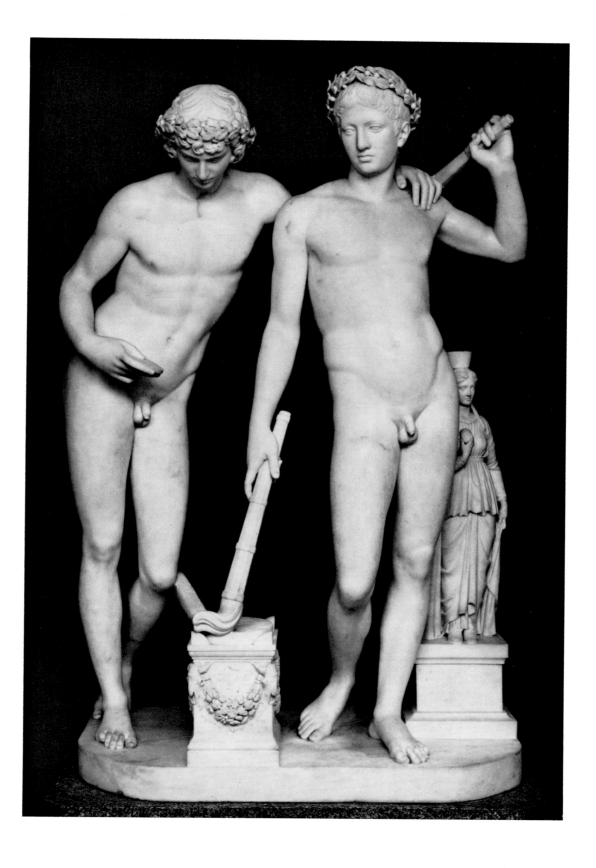

No. 35

Joseph NOLLEKENS
1737–1823

SIR GEORGE SAVILE
(1726–84)
1784

Bust in marble.
H. (including base)
2 ft 5½ in. (75·9 cm.)
A.16—1942
Given by Dr W. L.
Hildburgh, F.S.A.

Inscribed on the front of
the contemporary base:
Sir George Savile 1784,
and on the back:
Nollekens F.

Savile is shown looking to his left, with hair brushed back and curled behind the ears, the shoulders being covered with classical drapery.

Sir George Savile, 8th Baronet, was a well-known Whig politician who never held office, but who promoted the Catholic Relief Act of 1778. His bust is among those in the Mausoleum erected to the memory of the Marquis of Rockingham, leader of the Whig party, at Wentworth Woodhouse, Yorks. According to a contemporary record,[1] Nollekens took Savile's death mask, and at once made 'over six bust portraits' for his friends. The Museum's bust is probably one of these, another, though with blank eyeballs, being in the Fitzwilliam Museum, Cambridge. It is, however, impossible to say whether either is the version exhibited at the Royal Academy in 1785. This lively bust, with the eyeballs deeply incised, and the drapery arranged in a loop on the right side of the chest to counterbalance the movement of the head, is a characteristic example of Nollekens's art, and makes it easy to understand why he enjoyed so large a practice as a portraitist.

[1] Sophie von la Roche, *Sophie in London, 1786*, 1933, pp. 233 and 234. The bust also appears in the list of Nollekens's works in chap. XVII of J. T. Smith's *Nollekens and his Times*.

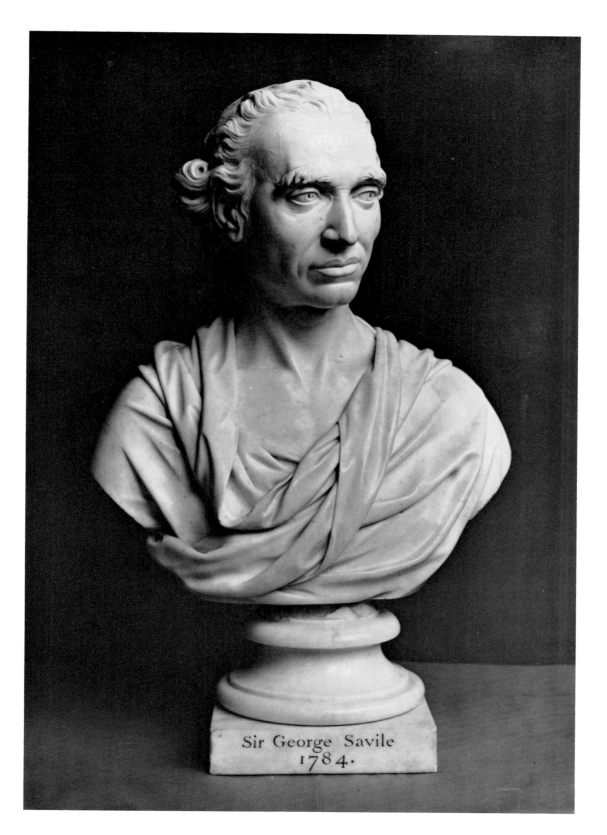

No. 36

Joseph NOLLEKENS
1737–1823

**A HERO DYING IN
THE ARMS OF
VICTORY**
Probably about 1790

**Sketch model in
terracotta.**
H. 8⅜ in. (21·3 cm.)
A.7—1944
**Given by Miss Zoë
Gordon-Smith**

A young man, nude except for a cloth over his loins, is semi-recumbent, leaning on his right arm. A winged Victory leans over him, supporting him with her right hand while with her left she hands him a palm. The wings of Victory are modelled separately and pinned on.

The group has been identified[1] as a sketch for the design exhibited in the Royal Academy in 1790 of *Lord Robert Manners expiring in the arms of Victory*, intended by the late Duke of Rutland for a monument to be placed in the Chapel at Belvoir Castle. This monument was never executed, but Lord Robert Manners had already been commemorated by a medallion portrait on Nollekens's monument to three Captains (Bayne, Blair and Manners) in Westminster Abbey. The group is probably linked with a sketch for the same subject in Nollekens's posthumous sale, but is unlikely, for the reasons given in connection with No. 37, to be identical with it.

Like the Laocöon (No. 39) the group is planned as a spiral composition, and is therefore one of the less classical of Nollekens's works.

[1] K. A. Esdaile 'A group of Terracotta Models by Joseph Nollekens', *Burl. Mag.*, vol. LXXXV, 1944, p. 221.

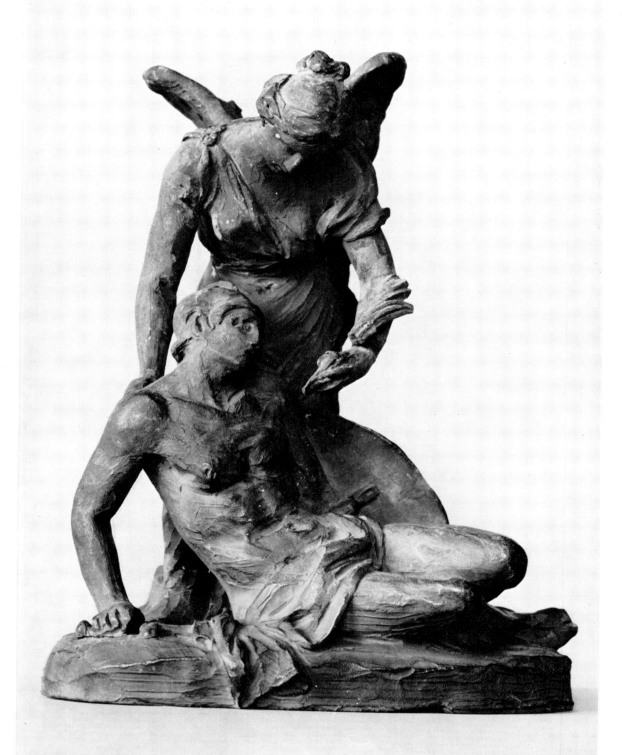

No. 37

Joseph NOLLEKENS
1737–1823

MRS HOWARD OF
CORBY AND HER
CHILD
Probably about 1800

Sketch model in
terracotta.
H. 5$\frac{3}{16}$ in. (13·2 cm.)
L. 9$\frac{11}{16}$ in. (24·6 cm.)
W. 4$\frac{1}{8}$ in. (10·5 cm.)
A.5—1944
Given by Miss Zoë
Gordon-Smith

Mrs Howard reclines, supported by her left arm, which rests on a cushion. She looks down at her new-born child held in her right arm.

This model has been identified[1] as a first sketch for the monument of Mrs Howard of Corby (dated 1803) in Wetheral Church, Cumberland (Fig. 6), and may be a version of the 'first Design for the Monument of Mrs. Howard', which was in Nollekens's posthumous Sale.[2] It is, however, unlikely that it was the piece then sold, since it was, traditionally, given by Nollekens to the ancestress of the donor.

The sketch, which has the vigour of all Nollekens's terracottas, differs considerably from the marble monument. In the latter the sentiment is increased, for Mrs Howard, who appears to be dying, is supported by the bending figure of Religion, who points upward with her right hand.[3] The cushion on which Mrs Howard rests has now disappeared, and her left arm trails on the ground. The child is still on her lap, but with the head in the opposite direction from the model. In 1800 Nollekens exhibited in the Royal Academy 'A monumental group, to the memory of a lady who died in child-bed, supported by Religion, etc.'.[4] This description conforms well enough to the marble, and it would be reasonable for it to take three years in execution. If, therefore, the terracotta is a first model, it is likely to be earlier than 1803, as suggested by Mrs Esdaile.

The marble, which is more classical in planning than the sketch, for both figures are almost parallel to the eye, is among Nollekens's most admired works. Henry Fuseli thought it superior to anything done by Canova,[5] and to Allan Cunningham it had 'more than the effect of a sermon'.[6] The latter also records that the marble cost £2,000. There is a design for the monument in the Department of Prints and Drawings.[7]

[1] K. A. Esdaile, 'A Group of Terracotta Models by Joseph Nollekens, R.A.', *Burl. Mag.*, vol. LXXXV, 1944, p. 221. [2] Christie's, 2nd Day's Sale, 4 July 1823, No. 41. [3] According to J. T. Smith, *Nollekens and his Times*, ed. Whitton, vol. II, 1920, p. 15, the figure of Religion was carved by his assistant, Goblet (see no. 51). [4] A. Graves, *The Royal Academy of Arts*, vol. V, 1906, p. 382, no. 1082.
[5] D. Irwin, *English Neoclassical Art*, 1966, p. 162, quoting 'Farington, *Unpub. Diary*, 13th January, 1804'. [6] A. Cunningham, *The Lives of the Most Eminent British Painters, Sculptors, and Architects*, vol. III, 1830, p. 175. [7] Physick, 44, fig. 20.

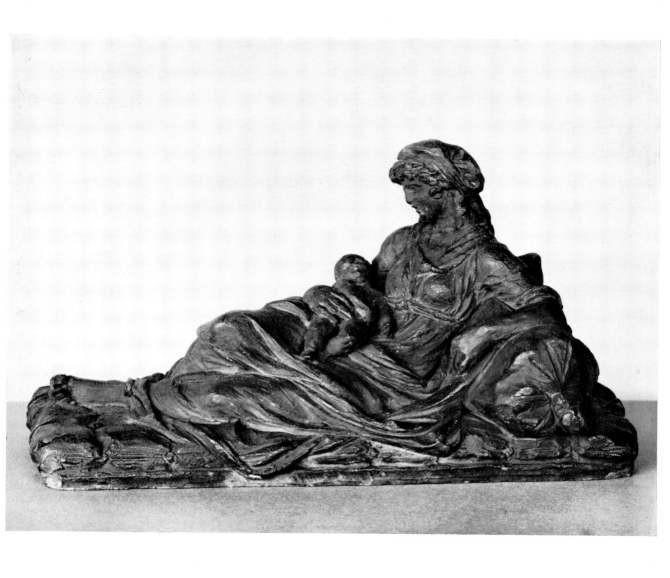

No. 38

Joseph NOLLEKENS
1737–1823

CHARLES JAMES FOX
(1749–1806)
Probably about 1802

Bust in marble.
H. (including base)
2 ft 4⅝ in. (72·7 cm.)
A.1—1945
Given by Dr W. L.
Hildburgh, F.S.A.

Signed on the back:
J. NOLLEKENS, R.A.
Sculp.

The sitter, with short hair, looks slightly to his right, with classical drapery over his shoulders, and a pleated garment beneath.

Nollekens is known to have made two busts of the famous statesman during his lifetime, one with a wig being exhibited at the Royal Academy in 1791,[1] and the second in 1802. Many replicas of both were made, those formerly in the possession of the Earl of Ilchester being dated 1793 and 1807.[2] J. T. Smith also records that Nollekens took a death mask of Fox, the result being 'ghastly', and 'totally unlike the features of Mr. Fox when living'.[3] There is little doubt that, in spite of the date on Lord Ilchester's bust, the second version was made from life, and that the Museum's bust is a good example of it. Though less dramatic than the earlier bust, it is nevertheless a powerful character study and a fine specimen of Nollekens's work.

[1] M. D. Whinney, *Sculpture in Britain, 1530–1830*, 1964, pl. 121 (dated 1792).
[2] Ilchester, *Cat. of Pictures belonging to the Earl of Ilchester at Holland House*, privately printed, 1904, p. 138. [3] J. T. Smith, *Nollekens and his Times*, ed. Whitton, vol. I, 1920, p. 381, where the second bust is erroneously regarded as posthumous.

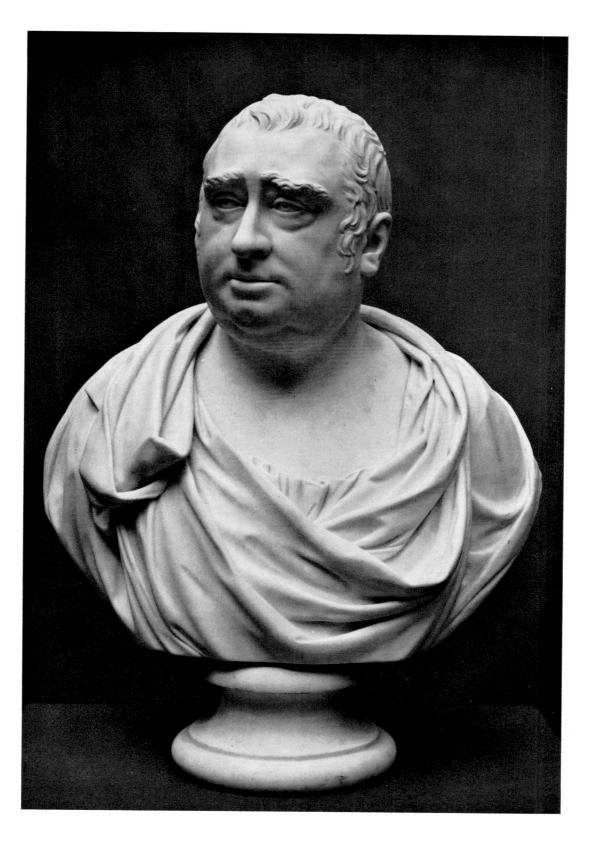

No. 39

Joseph NOLLEKENS
1737–1823

LAOCÖON AND HIS
SONS
Probably 1805

Sketch model in
terracotta.
H. 10¼ in. (26 cm.)
A.12—1966
Purchased under the
Bequest of Dr W. L.
Hildburgh, F.S.A.

The naked, bearded Laocöon stands with bowed shoulders between his two young sons, with his right foot advanced, and looking downwards at the boy on his left. He places his right arm on the shoulder of the boy on his right, who stands with his right arm raised. Laocöon grasps with his raised left hand one of the two serpents which are attacking them, while the second boy, seated on the ground, clings to his father's left leg. The three figures are bound together within the coils of the serpents.

The composition is freely adapted from the famous Hellenistic Group in the Vatican, Rome, but is entirely different in conception. In the antique model the three figures are set out in line as on a frieze, so that the group has only one view point, and the sons are young adolescents. The present group is tied together in the form of a spiral and there is an additional note of sentiment in the idea of the young children meeting their doom.

Nollekens exhibited a sketch of Laocöon and his sons in the Royal Academy of 1805,[1] and, as he was in the habit of using the word to denote a sketch-model, it is possible that this was the exhibit in question. Drawings related to it are in the Museum (E.572 and E. 573–1950), and a further drawing, in which the pose of Laocöon's arms differs from the model, is in a Nollekens Sketch book in the Ashmolean Museum, Oxford. In the posthumous sale of his collection, among PENSIERI IN TERRA COTTA, BY MR. NOLLEKENS, is 'A Group of Laocoon,—treated differently from the antique'.[2]

J. T. Smith, the biographer of Nollekens, records: 'The greatest pleasure our Sculptor ever received was when modelling small figures in clay, either singly or in groups, which he had baked; and in consequence of his refusing to sell them, and giving very few away, they became so extremely numerous, that they not only afforded a great display of his industry, but considerable entertainment to his friends.'[3]

[1] A. Graves, *The Royal Academy of Arts*, vol. V, 1906, p. 382, no. 694. [2] Christie's Sale, Friday, 4 July 1823, Lot 35. [3] J. T. Smith, *Nollekens and his Times*, ed. Whitton, vol. I, 1920, p. 347, quoted by K. A. Esdaile, 'A Group of Terracotta Models by Joseph Nollekens, R.A.', *Burl. Mag.*, vol. LXXXV, 1944, pp. 220–23.

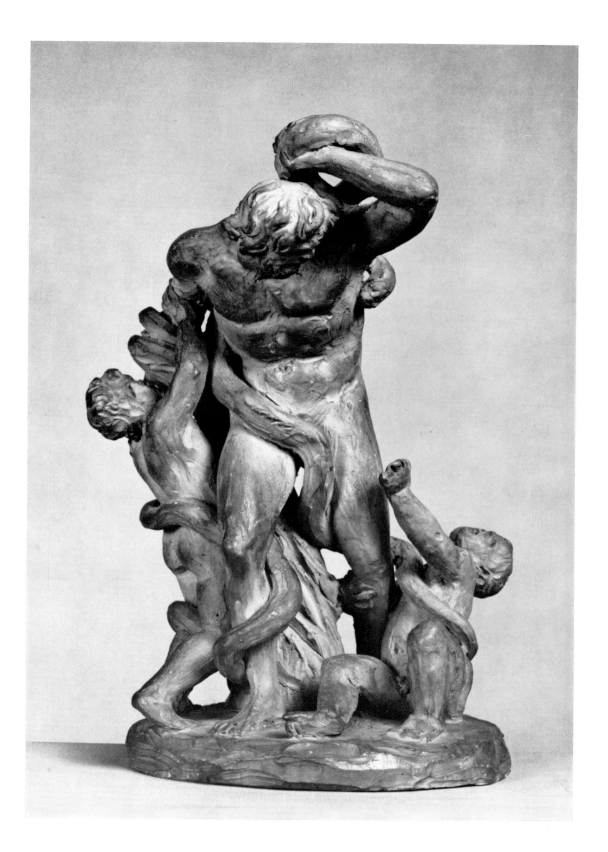

Thomas BANKS 1735–1805

Banks was apprenticed to an ornamental carver whose shop was close to the studio of Peter Scheemakers (q.v.), where he obtained permission to draw and model in the evenings. From 1763 until 1769 he exhibited at the Royal Society of Arts, obtaining prizes for his work, and in the summer of 1769 was admitted to the Royal Academy Schools, gaining a Gold Medal in 1770, and a travelling studentship in 1772. By then he had married a wife who had money, and they were able to stay in Rome for seven years. During this time he became intimate with the painter, Henry Fuseli, who in 1765 had translated into English that basic text book of Neoclassicism, Winckelmann's *Gedanken über die Nachahmung der griechischen Werke*, 1755, as *Reflections on the Painting and Sculpture of the Greeks*. Banks made several works in Rome, among them No. 40, then, after his return to England in 1780, paid a short visit to Russia in the hope of obtaining the patronage of Catherine the Great. He was, however, disappointed and was back in England by 1782. He was made an A.R.A. in 1784 and an R.A. in the next year. He obtained a considerable number of commissions for monuments, some being much admired, and also made busts, few of which have survived. His talents were rated very highly by his fellow artists, Reynolds regarding him as 'the first British sculptor who had produced works of classic grace', and as one whose 'mind was ever dwelling on subjects worthy of an ancient Greek', and as the first English neoclassical sculptor his work has indeed considerable importance; but it is very uneven in quality. His best work is probably his least pretentious, though, like that of many neoclassical artists, it is infused with a sentiment which today is somewhat cloying. His more ambitious works, on the other hand, notably his two monuments in St Paul's Cathedral, attempt the heroic but end very near to the ridiculous.

C. F. Bell, *Annals of Thomas Banks*, 1938: M. D. Whinney, *Sculpture in Britain, 1530–1830*, 1964, pp. 175–82.

No. 40

Thomas BANKS
1735–1805

THETIS AND HER NYMPHS RISING FROM THE SEA TO CONSOLE ACHILLES FOR THE LOSS OF PATROCLUS
Probably 1778

Relief in marble. Oval. H. 3 ft (91·4 cm.). L. 3 ft 10¾ in. (118·7 cm.) Presented by the artist's daughter, Mrs Lavinia Forster, to the National Gallery. Transferred to the Tate Gallery early in the twentieth century, and placed on indefinite loan at the Victoria and Albert Museum in 1936.

Achilles, nude and in high relief, lies stretched across the oval. He rests partly on his left arm, and partly in the lap of a kneeling warrior, who supports him. His right arm is raised in a gesture of desolation to his head. Below him is a horizontal shelf, curving up to the right. Under this projection there is a slight indication of waves in low relief, and from the bottom right to the top left is a great curve, composed of the bodies of Thetis and seven nymphs, some in low and some in high relief.

The marble, the plaster model of which is in the Soane Museum, was begun during Banks's stay in Rome, and is probably the commission from the Earl of Bristol and Bishop of Derry which was left on the sculptor's hands; for it was still in his studio at his death.[1]

The subject is taken from the *Iliad*, and the style, with the figures for the most part silhouetted against a plain ground, reveals not only Banks's study of the antique, but also his position as the first English neoclassical sculptor. Nevertheless, there is an emotional intensity in this work, seen both in the gestures and in the design; the treatment of form is far from the calm detachment of antique sculpture and recalls the fact that Banks's closest friend in Rome was the dramatic painter, Henry Fuseli.[2]

[1] C. F. Bell. *Annals of Thomas Banks*, 1938, pp. 35, 40, 41. [2] M. D. Whinney, *Sculpture in Britain, 1530–1830*, 1964, p. 176 and pl. 137.

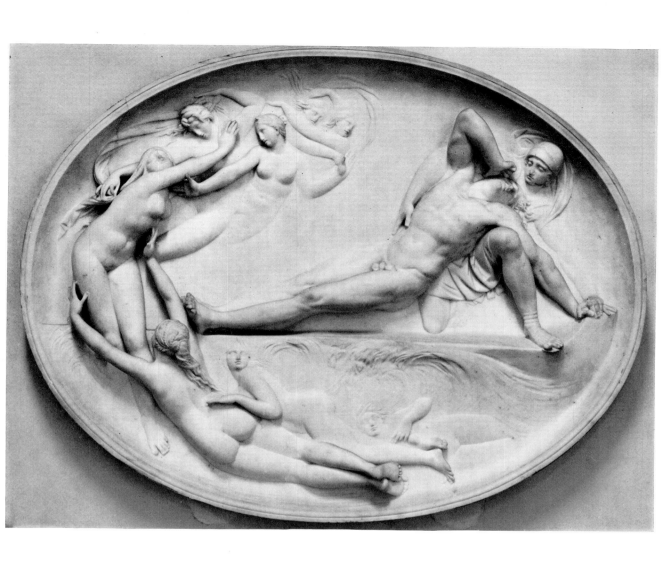

No. 41

Thomas BANKS
1735–1805

**THETIS DIPPING
ACHILLES IN THE
RIVER STYX**
1790

**Group in marble.
H. (including base)
2 ft 9⅝ in. (85.4 cm.).
L. 3 ft 2½ in. (97.8 cm.)
A.101—1937
Given by C. F. Bell, Esq.**

Thetis, semi-nude, is shown half-kneeling, half-standing, on the banks of the Styx. In her right hand she holds the infant Achilles upside down by his right ankle, while with her left she prevents her drapery, which is looped over her right arm, from slipping down. Her hair is loosely coiled and knotted on the top of her head. The base is decorated in relief with combat scenes between the monsters of the Styx.

The group was commissioned by Colonel Thomas Johnes, of Hafod, M.P. for Radnorshire, one of Banks's best patrons.[1] The heads of the two figures are those of his wife and infant daughter. It escaped the disastrous fire at Hafod in 1807, when other works by Banks and the valuable library were destroyed, and was bought with the house by the Duke of Newcastle in 1833. It remained in his possession till 1937, when it was bought by Mr Charles Bell,[2] a descendant of the artist, and presented to the Museum. The discoloration on the left side of Thetis is not due to the fire, for the spots visible are the natural markings of the marble.

The work is one of the few surviving finished statues by Banks, and shows at once his strength and his weakness. The design, with its fluid curves, is accomplished, and, though it is an exercise in the classical manner, is by no means a tame repetition of an Antique figure; and the fighting monsters on the base show Banks's felicity in linear design. Nevertheless, the group as a whole is a trifle clumsy, for the proportions are unhappy. The hands and feet of Thetis are too large and, compared with her massive figure, the child is too small. There is, too, something uncomfortable in the scale of the whole. Although, like the artist's *Falling Titan* (Royal Academy of Arts), it is a small work, reproductions give the impression of a figure on a heroic scale instead of a small decorative piece.

[1] C. F. Bell, *Annals of Thomas Banks*, 1938, p. 75 ff.; E. Inglis Jones, *Peacocks in Paradise*, 1950, p. 98; M. D. Whinney, *Sculpture in Britain, 1530–1830*, 1964, p. 178 and pl. 138. [2] Clumber Sale (Christie's), 19 October 1937, Lot 337.

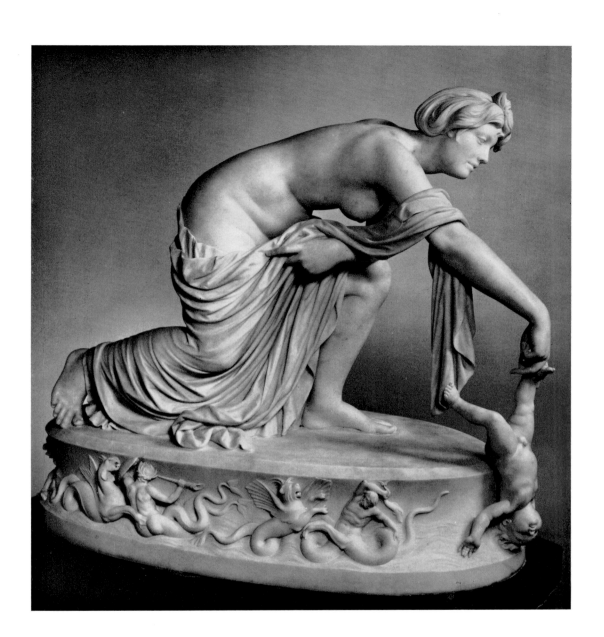

No. 42

Thomas BANKS
1735–1805

DR ANTHONY
ADDINGTON (1713–90)
1791

Bust in marble.
H. (including base)
2 ft 5½ in. (74·9 cm.)
A.2—1955
Given by Dr W. L.
Hildburgh, F.S.A.

The subject wears his own hair and a classical tunic laced on his right shoulder and with an embroidered border to his right sleeve. His left shoulder is covered by thicker folds of drapery.

Dr Anthony Addington, the father of the Speaker, Henry Addington, afterwards Prime Minister, had practised in London, the great Earl of Chatham being among his patients. His son, who became the first Lord Sidmouth, acquired Up-Ottery Manor, Devon, from which the bust was sold in 1954.

According to Joseph Farington, who saw it in the Speaker's House, it was made from a death mask, but 'so like that Mr. Pitt said it was the only bust he could ever talk to'.[1]

It is certainly the most distinguished remaining bust by Banks. While it follows, broadly speaking, a classical pattern, it has a liveliness and a strength of characterization which are unusual in a posthumous bust and make it surprising that the sculptor did not get more commissions.

[1] C. F. Bell, *Annals of Thomas Banks*, 1938, p. 84, quoting Joseph Farington, *Unpublished Diary*, 3 Jan. 1798.

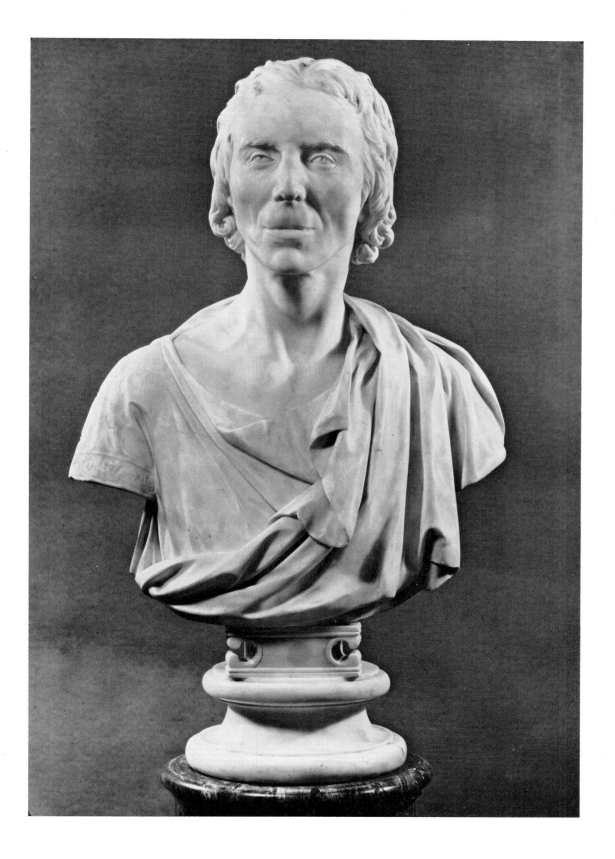

No. 43

Thomas BANKS
1735–1805

ACHILLES ARMING

Statuette in terracotta.
H. 1 ft 6 13/16 in. (47·8 cm.)
A.22—1955
Given by Reginald H.
Pott, Esq.

Achilles, nude, stands with his left leg forward and both arms raised, and holds a helmet, which he places on his head. Behind him, on the base are a cuirass and shield.

The date and purpose of this work are unknown,[1] though it was described by Allan Cunningham as 'Achilles arming amidst his Myrmidons. He is represented placing on his head that helmet which was never soiled with dust.'[2] The style suggests that it may be a relatively early work, for the elongation of the figure and the nervous intensity of the pose and above all of the glance, recall the art of Banks's friend, the painter Henry Fuseli. This might well, therefore, have been made in the 1780s, for the influence of Fuseli is less strongly apparent in works dated after 1790.

[1] C. F. Bell, *Annals of Thomas Banks*, 1938, p. 193. [2] Allan Cunningham, *The Lives of the Most Eminent British Painters, Sculptors, and Architects*, vol. III, 1830, p. 109.

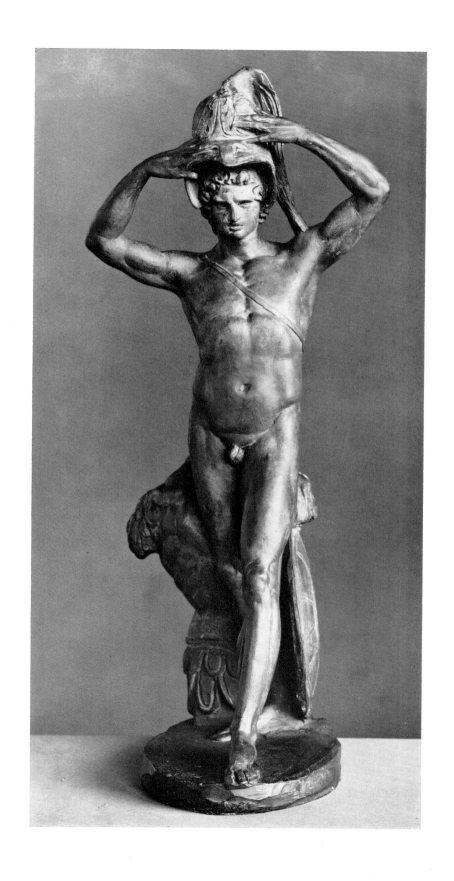

John FLAXMAN 1755–1826

Flaxman was the son of a maker of models and casts who worked for the leading sculptors about the middle of the century. By 1767 he began to exhibit plaster models of classical figures at the Society of Arts, and in 1769 he entered the Royal Academy Schools. He soon became friendly with Thomas Stothard and William Blake, and was led by the latter to an appreciation of medieval art. After leaving the Academy Schools he worked with his father for the Wedgwood factory, and the discipline needed for the production of suitable designs strengthened his innate talent for linear rhythm. By the 1780s he was obtaining commissions for monuments and by 1787 had saved enough to go with his wife to Rome. Since he found patrons he was able to prolong his stay for seven years, during which time he not only studied the Antique but, as his Sketch Books in the Museum show, both Italian medieval and renaissance art.

While in Rome he produced the first of his book illustrations, which were to make him famous and also extremely influential throughout Europe. His Homer appeared in 1793, followed by an Aeschylus in 1795 and a Dante in 1802, in all of which his gifts for linear design are fully displayed.

On his return to England in 1794 he soon built up a good practice, chiefly for monuments, both large and small, though he also made both statues and busts. He became an A.R.A. in 1797, an R.A. in 1800, and Professor of Sculpture at the Royal Academy in 1810. His published lectures to the students, though not adroitly phrased, give full insight into his artistic creed. His devotion to antiquity was the basis of his art, but he was infused, above all, by a moral purpose. This is displayed in his many small monuments, a surprising number of which use the theme of reading, while others are concerned with the comforts of religion. His work was clearly immensely popular, his charges were not high and he consequently drew patrons from many sections of the community. The execution of some of his marbles is a little dull, for they were largely carried out by assistants. His plaster models, which were cast from his own designs in clay, frequently show more sensitive handling.

His strength lies in the immense variety of his designs, both in high and low relief. He was, perhaps, less successful in large-scale work, but he was greatly admired by his contemporaries, who

praised him for his poetic approach. Indeed, though Flaxman is generally regarded as the foremost English neoclassical sculptor, much of his work displays characteristics which link him with early romanticism.

W. G. Constable, *John Flaxman*, 1927; M. D. Whinney, *Sculpture in Britain, 1530–1830*, 1964, chapters 19, 23 and 24; M. D. Whinney and R. Gunnis, *The Collection of Models by John Flaxman R.A. at University College London*, 1967.

No. 44

John FLAXMAN
1755–1826

SELF-PORTRAIT
1778

Relief in terracotta.
Diameter (overall) 7⅜ in.
(18·7 cm.)
294—1864

Inscribed round the rim:
HANC SVI IPSIVS
EFFIGIEM FECIT
IOANNES FLAXMAN
IVNIOR ARTIFEX
STATVARIVM ET
CŒLATOR
ALVMNVS EX
ACADEMIA REGALE
ANNO ÆTATIS XXIV
A.D. MDCCLXXVIII

The head is shown full-face, in high relief, with hair falling to the shoulders. The sitter wears contemporary dress.

This early work, which was shown at the Royal Academy in 1779, is both firm and naturalistic, though the eyeballs are not incised. Flaxman had entered the Royal Academy Schools in the autumn of 1769, but had failed to win the Gold Medal he hoped for in 1773. He had joined his father, a modeller at that time working chiefly for Joseph Wedgwood, but, though he was still working for Wedgwood in 1778, it seems unlikely, owing to the depth of the relief, that this portrait was intended for reproduction by the Wedgwood factory.[1]

By 1789, the portrait was in the possession of Sir William Hamilton in Naples, but it is not known when or how he acquired it.[2] He is, however, known to have been in touch with Flaxman when the artist was in Italy.

[1] W. G. Constable, *John Flaxman*, 1927, pp. 23, 80, 116 and pl. IX, where the medium is wrongly described as wax. The cast mentioned by Constable as in the Soane Museum is still there, but that said to be at University College, London, no longer exists. [2] O. E. Deutsch, 'Sir William Hamilton's Picture Gallery', *Burl. Mag.*, vol. LXXXII, 1943, p. 38.

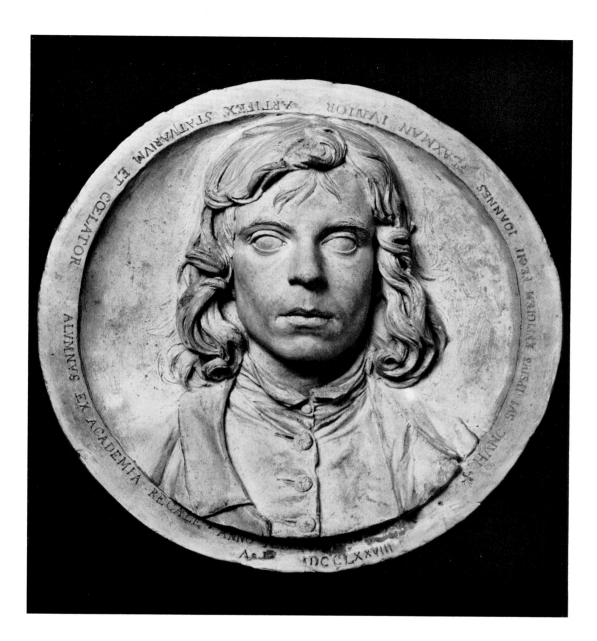

No. 45

John FLAXMAN
1755–1826

THE ANCIENT
DRAMA
1809

Two reliefs in plaster.
H. (excluding frame)
1 ft 3⅜ in. (39·1 cm.).
L. (excluding frame)
6 ft 1 in. (185·4 cm.)
A.8—1968
H. (excluding frame)
1 ft 3⅜ in. (39·1 cm.).
L. (excluding frame)
5 ft 11 3/16 in. (180·8 cm.)
A.9—1968
Given by H. Barrs-Davies,
Esq.

The left half represents Greek Comedy and the right Greek Tragedy. In the centre, facing left, are seated figures of Aristophanes and Menander, masters of Greek Comedy. In front of them stands Thalia, the Comic Muse, with her mask and shepherd's crook, while behind her, moving in procession, are Polyhymnia, Euterpe and Clio, playing musical instruments, and Terpsichore dancing. At the end, facing outwards, are three nymphs crowned with pine cones, representing the Hours and Seasons, who attend the winged horse Pegasus, a symbol of immortality.

The seated figure in the centre facing right is Aeschylus, the greatest of Greek tragedians, his attention fixed on Athena in her role as Wisdom. Between them, leaning on his faun, is Bacchus, in whose honour the Greeks presented tragedies. Behind Athena stands Melpomene, the Muse of Tragedy, holding her mask, and then a scene facing outwards. This, which is taken from the *Eumenides* of Aeschylus, shows two Furies pursuing Orestes, who flees for protection towards the chariot of Apollo.

Nos. 45 and 46 are casts from the original models for two friezes, which Flaxman was commissioned to design for the façade of Covent Garden Theatre in 1809. They were to be set on either side of the portico, *The Ancient Drama* being to the north. His Account Book, now at Columbia University, New York, shows that he made a model for this frieze, but a drawing only for *The Modern Drama* (No. 46).[1] Both friezes were cut in stone by the sculptor, John Charles Rossi (1762–1839), a protégé of the architect of the theatre, Robert Smirke.[2]

In 1856 the theatre was seriously damaged by fire but the sculpture was saved. On the new building by E. M. Barry the friezes were reset behind the portico and the order of the scenes was changed so that the subjects are now much confused. Fortunately a drawing by John Wykeham Archer in the British Museum records their original sequence, which is identical with Nos. 45 and 46.

The designs have considerable importance in the history of English sculpture, for they are probably the first example of the direct influence of the Elgin Marbles. In 1807 Flaxman had inspected the Marbles at Lord Elgin's house in Park Lane, and had advised against any attempt at restoration.[3] The treatment of Apollo's chariot and of the procession of Muses reveals the deep impression they had made on him. One figure only is based on a Roman source; for the seated Menander is taken from the seated statue of that dramatist in the Vatican.

[1] M. D. Whinney and R. Gunnis, *The Collection of Models by John Flaxman R.A. at University College London*, 1967, pp. 60, 61 and pl. 21. The College originally owned models of both friezes, formerly catalogued as by Flaxman. Only two slabs of *The Ancient Drama* and none of *The Modern Drama* survived the Second World War. These appear to be later casts from the same mould as No. 45, for they are less fine in modelling and some of the detail has been lost. [2] *Gentleman's Magazine*, vol. 79, ii, 1809, p. 880 ff., which gives a detailed account of the work. [3] A. H. Smith, 'Lord Elgin and his Collection', *Journal of Hellenic Studies*, vol. XXXVI, 1916, pp. 297–98.

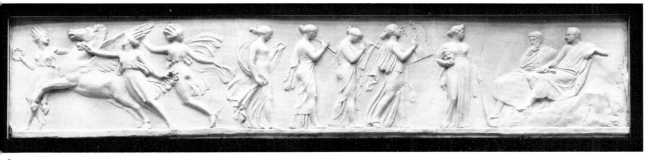

left section

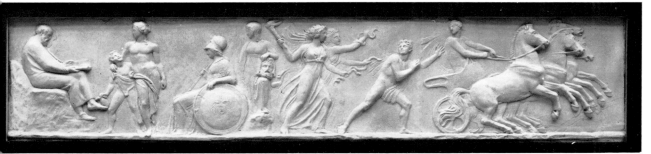

right section

No. 46

John FLAXMAN
1755–1826

THE MODERN DRAMA
1809

Two reliefs in plaster.
H. (excluding frame)
1 ft 3⅜ in. (39·1 cm.).
L. (excluding frame)
5 ft 8½ in. (174 cm.)
A.10—1968
H. (excluding frame)
1 ft 3⅜ in. (39·1 cm.).
L. (excluding frame)
5 ft 6⅛ in. (168 cm.)
A.11—1968
Given by H. Barrs-Davies, Esq.

The subjects are taken from Shakespeare and Milton, the general arrangement, reading from the centre outwards, being similar to that of *The Ancient Drama* (No. 45). In the centre, facing left, Shakespeare is seated on a mound with his right arm raised, as if summoning his characters. Below him are Tragic and Comic masks and a lyre. Next, moving away from him towards the left, are figures from *The Tempest*, Caliban carrying a heavy load of wood, Ferdinand sheathing his sword and Miranda entreating Prospero to welcome him. In front is Ariel, floating above with a lyre. The next scene is from *Macbeth*. The corpse of Duncan lies on the ground. Macbeth, covering his face in horror, turns from it to Lady Macbeth, who holds two daggers in her hands. At the end is Hecate, the three-formed goddess, her chariot drawn by oxen, descending to the Underworld.

Balancing Shakespeare in the centre and facing right, Milton is contemplating the Muse Urania,[1] who is seated awkwardly in the sky. At Milton's feet is Samson Agonistes, bound. The rest of the frieze shows figures from *Comus*. First are two brothers with swords, driving out three Bacchantes and their staggering leader, Comus. Beyond is the Enchanted Lady, seated in a chair, and the scene ends with two tigers, representing the transformation of the devotees of Comus.

The whole of this frieze is squared, the squares being numbered from right to left, though the numerals are now legible on one panel only. There is also an unexplained caricature head drawn on the ground close to the legs of Caliban.

The squaring and numerals, which appear on this frieze only, seem to record the marks made by John Charles Rossi on his ground to facilitate the enlargement of Flaxman's drawing (see No. 45). The modelling is very close in handling to that of *The Ancient Drama*, and shows how far Rossi was prepared to copy Flaxman's style. It is probably because the friezes were a pair that the romantic subjects of *The Modern Drama* are treated in a classical manner, though the influence of the Elgin Marbles is less evident than in No. 45. Most of the figures are shown in classical dress; but the brothers in the *Comus* scene and Ferdinand from *The Tempest* make a slight concession to more modern fashion with their tights, cloaks and shoes. On the other hand, the curious range of dress in the exhibits at Boydell's Shakespeare Gallery (sold in 1805) shows that there was as yet little real understanding of historical costume.[2]

[1] Milton, *Paradise Lost*, Bk. VII, lines 1–40. [2] T. S. R. Boase, 'Illustrations of Shakespeare's Plays in the Seventeenth and Eighteenth Centuries', *Journal of Warburg & Courtauld Institutes.*, vol. X, 1948, p. 83; T. S. R. Boase, *English Art, 1800–1870*, 1959, p. 2.

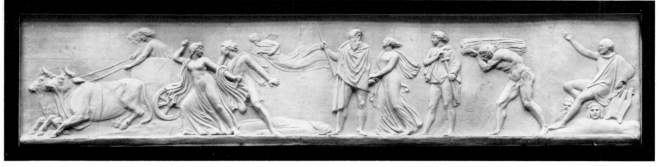

Left section

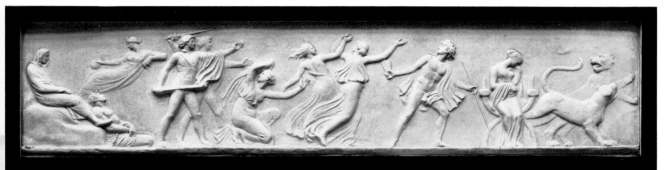

Right section

No. 47

John FLAXMAN
1755–1826

ST MICHAEL
OVERCOMING SATAN
Probably 1819

Statuette in plaster.
H. (to right hand of St
Michael) 2 ft 6⅝ in.
(77·8 cm.)
312—1898
Given by Dr W. Stuart

St Michael, nude and without wings, stands on his left leg, the right swinging out behind him, and strikes with his spear at Satan, who is writhing at his feet. A small drapery covers St Michael's loins and right hip, and curves downwards to the serpent coils, which represent the lower part of Satan's body.

This plaster is the sketch model for the marble group made for the 3rd Earl of Egremont between 1819 and 1826, and delivered after Flaxman's death to Petworth House, where it still remains. The full-size model at University College, London,[1] shows a number of small changes in design, such as the transfer of the drapery to St Michael's left leg, and in the arrangement of the coils of the serpent, thus making it certain that the Museum's small plaster is earlier than the large model. It was only in his later years that Flaxman developed the practice of making full-size models. Earlier he had expected his assistants to make large works from small models, but this led to so much trouble, notably in the case of the monument to Earl Howe in St Paul's Cathedral (1803–11), that he was compelled to abandon this method.

The *St Michael overcoming Satan* was one of his last works, and though the figure of the saint reveals Flaxman's profound admiration for Antiquity, the composition has certain links with sixteenth-century Italian sculpture, such as Benvenuto Cellini's 'Perseus', of which Flaxman made drawings when he was in Italy. The spiral movement is, however, to some extent broken by the sharp vertical of the spear.

The work was much admired by Flaxman's contemporaries, Allan Cunningham noting: '—all is elevated—there is nothing low—there is much to excite awe, and nothing to disgust.'[2] It is, indeed, Flaxman's final and perhaps most successful attempt to achieve a heroic work.

[1] M. D. Whinney and R. Gunnis, *The Collection of Models by John Flaxman R.A. at University College London*, 1967, no. 88 and pl. 24B. [2] Allan Cunningham, *The Lives of the Most Eminent British Painters, Sculptors, and Architects*, vol. III, 1830, p. 355.

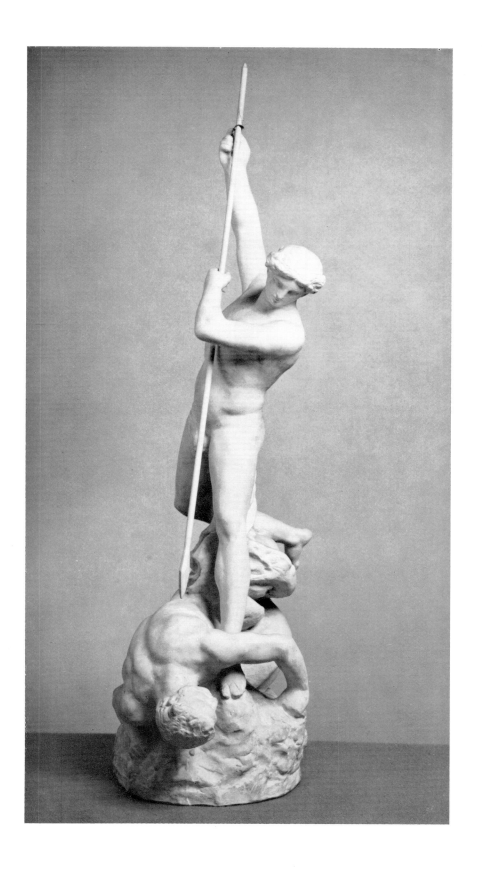

Sir Francis CHANTREY 1781–1841

Chantrey, unlike most sculptors of his time, had no period of study in Italy and, indeed, little formal training. He was born near Sheffield in modest circumstances, and first attempted to become a portrait painter. For a short time after 1802 he was an intermittent student at the Royal Academy Schools, but most of his early work was done in Sheffield. By 1809 he had settled in London and had married a wife with money. His first major success was the strong but naturalistic bust of Horne Tooke (Fitzwilliam Museum, Cambridge) exhibited at the Royal Academy in 1811. Thereafter he was never to want for commissions. In 1816 he was elected an A.R.A. and became an R.A. two years later.

For the rest of his life a stream of works flowed from his studio in Pimlico—statues, monuments and busts, the best being among the finest examples of English sculpture. He had a great gift for characterization, his ability to render the softness of flesh was much admired, his love of large, rather than small, broken forms gives his work a strength and dignity which is impressive. Though compelled by the fashion of his day to produce, on occasions, classicizing works, his robust common sense and his enormous talent is better displayed in works which combine an almost classical simplicity of form with naturalness in presentation. He lacks Flaxman's supreme gift of linear design, but has far stronger sense of form.

He was knighted by William IV in 1837, and left his considerable fortune to Lady Chantrey for her life; after her death to the Royal Academy for the purchase of works by British artists for the nation.

G. Jones, *Sir Francis Chantrey, R. A. Recollections of his Life, Practice and Opinions*, 1849; J. Holland, *Memorials of Sir Francis Chantrey*, 1851; M. D. Whinney, *Sculpture in Britain, 1530–1830*, 1964, pp. 217–27.

No. 48

Sir Francis CHANTREY
1781–1841

JOHN RAPHAEL
SMITH (1752–1812)
1825

Bust in marble.
H. (including base)
2 ft 3 $\frac{5}{16}$ in. (69·4 cm.)
A.15—1920
Given by Mrs O. Stuart
Andreae and Miss South

Inscribed on the back:
CHANTREY, SC.1825

The sitter, wearing a soft cap with a tassel, under which his hair shows at the sides and back, looks to his half-left, with his mouth slightly open, as if speaking. A cloth is thrown over his shoulders, leaving his chest bare.

John Raphael Smith, painter and mezzotint engraver, had first met Chantrey in Sheffield when the sculptor was quite young.[1] He proved a good friend when Chantrey settled in London, helping him to meet likely patrons.

The bust, though dated 1825, thirteen years after Smith's death, was probably based on an earlier model made from life. Holland records[2] that Chantrey, while still in Sheffield, modelled a bust, which remained in his studio, but was 'multiplied by casts'. He exhibited a bust of Smith in the Royal Academy in 1811.[3] His Ledger, owned by the Royal Academy, shows that he was commissioned in 1824 to execute the bust in marble for Sir Simon Clarke, and that the charge, entered on 16 December 1827, was £105. 0. 0. A further note, dated 14 February 1835, reveals that it remained on Chantrey's hands.

The portrait is among the sculptor's most striking works. It shows his ability, for which he was so much praised, in rendering the softness of flesh, and also reveals his gift of conveying character. Smith was deaf, and 'the peculiarity of listening is conveyed with unmistakable precision',[4] by the turn of the head, the straining of the eyes, and the slightly open mouth.

[1] G. A. Jones, *Sir Francis Chantrey, R.A. Recollections of his Life, Practice and Opinions*, 1849. [2] J. Holland, *Memorials of Sir Francis Chantrey*, 1851, p. 43.
[3] A. Graves, *The Royal Academy of Arts*, vol. II, 1905, p. 40. [4] John Holland *op. cit.*, p. 219.

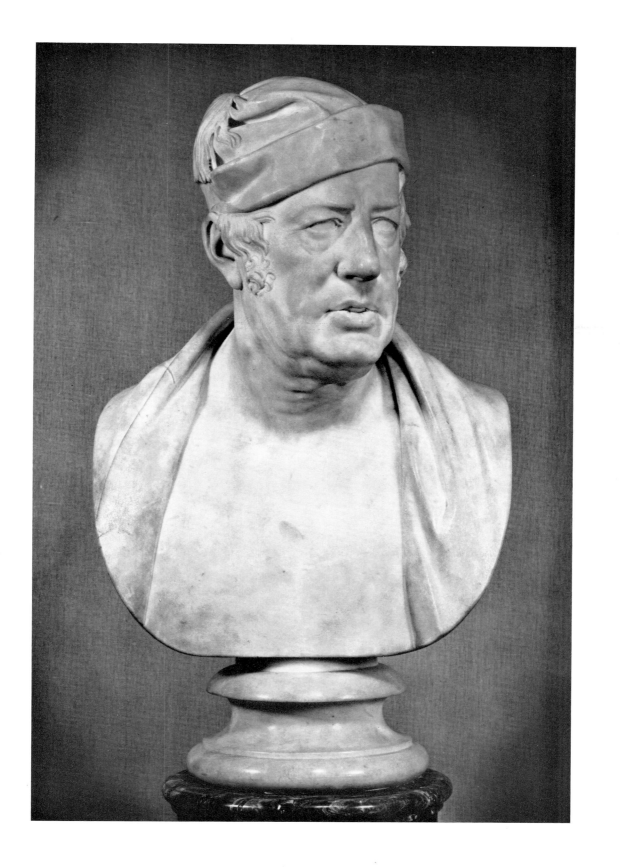

No. 49

Sir Francis CHANTREY
1781–1841

WILLIAM STUART,
ARCHBISHOP OF
ARMAGH
(1755–1822)
1828

Bust in marble.
H. (including base)
2 ft 4½ in. (72·4 cm.)
A.137—1956

Inscribed on the back:
CHANTREY, SC.1828

The sitter, bare-headed and with hair receding from his forehead, looks to his half-right. His shoulders and chest are enveloped in a cloak; his throat is bare.

The identification of the sitter rests on a plaster in the Ashmolean Museum, Oxford, which appears to be on its original pedestal, which is inscribed: STUART, ARCHBp of ARMAGH. Chantrey's Ledger in the Royal Academy records the order in 1824 of a bust of the late Archbishop, by his son, and its completion in 1825. The date 1828 on the back of the present bust remains unexplained. It could be a second version, or possibly suggest delay in delivery, but the latter can usually be deduced from the Ledger entries. The bust is a good example of Chantrey's variant of the classicizing formula. The drapery, though indeterminate in character, is arranged in straight falling folds, and so gives a hint of a contemporary cloak; but the bare throat remains true to classical convention.

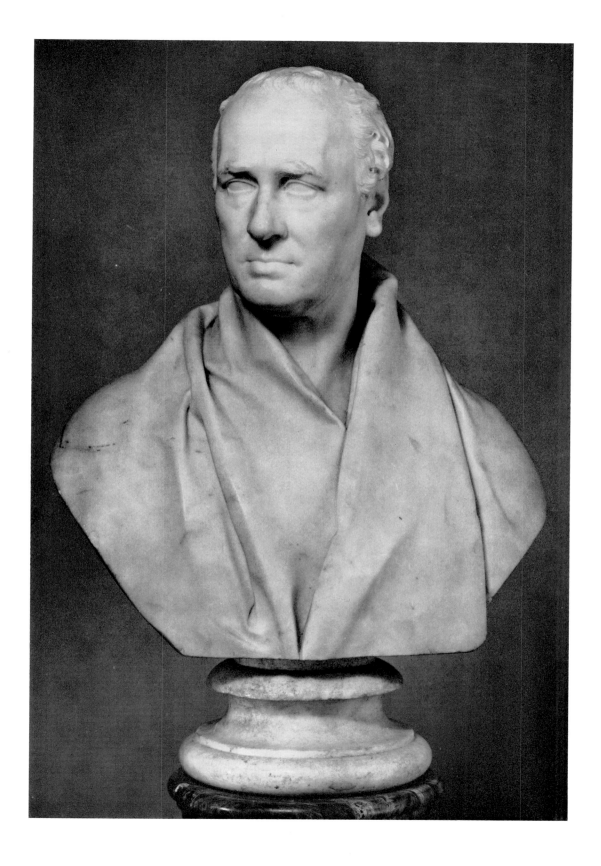

No. 50

Sir Francis CHANTREY
1781–1841

REGINALD HEBER,
BISHOP OF
CALCUTTA (1783–1826)
About 1827

Sketch model in clay.
H. 9⅜ in. (23·8 cm.)
A.29—1933
Given by Mrs Hugh
Chisholm

The Bishop in his robes kneels on a cushion, his head slightly bent forward. His left hand is on his breast; his right, holding a scroll, hangs at his side. Roughly scratched on the front of the base is the figure 3.

Sketch model for the marble monument to Bishop Heber, 2nd Bishop of Calcutta, for St Paul's Cathedral, Calcutta. The monument was ordered in March 1827 and completed in 1835, the price being £2,000 including the pedestal.[1] It was at first erected in St John's Church, Calcutta, and removed to the newly-built Cathedral in about 1847. A replica, paid for by public subscription, was ordered for St Paul's Cathedral, London (Fig. 7), in September 1828 and completed in 1835. It is now in the crypt. The cost of this was £3,000, the difference presumably being due to the fact that it has a larger and more elaborate pedestal than the Calcutta figure, with a relief of Bishop Heber blessing two Hindus. The latter had been used by Chantrey on his monument to Heber, made between 1827 and 1831 for St George's Church, Madras.[2]

Both the executed statues differ from the sketch, chiefly in the position of the arms, where the action is reversed. The right hand is on the breast and the left grasps a Bible, which rests on the cushion. In both monuments Heber's coat of arms as Bishop of Calcutta appear on the pedestal below the cushion. The monuments are fine examples of Chantrey's more naturalistic and less classical manner,[3] and the rough sketch shows his method of concentrating on broad forms. In the marble the folds of, for instance, the sleeves are smaller and more complicated, but the general simplicity of treatment matches the simplicity of the conception, and the whole has great dignity.

[1] The dates and prices of the various commissions are taken from Chantrey's Ledger at the Royal Academy. [2] *The Life of Reginald Heber*, by his widow, vol. II, 1830, frontispiece. The same volume, pp. 493–94 records the opening of the subscription of the London monument in 1827. [3] For a description of the Calcutta monument, see C. R. Wilson, *List of Inscriptions . . . in Bengal*, 1896, p. 1, no. 1.

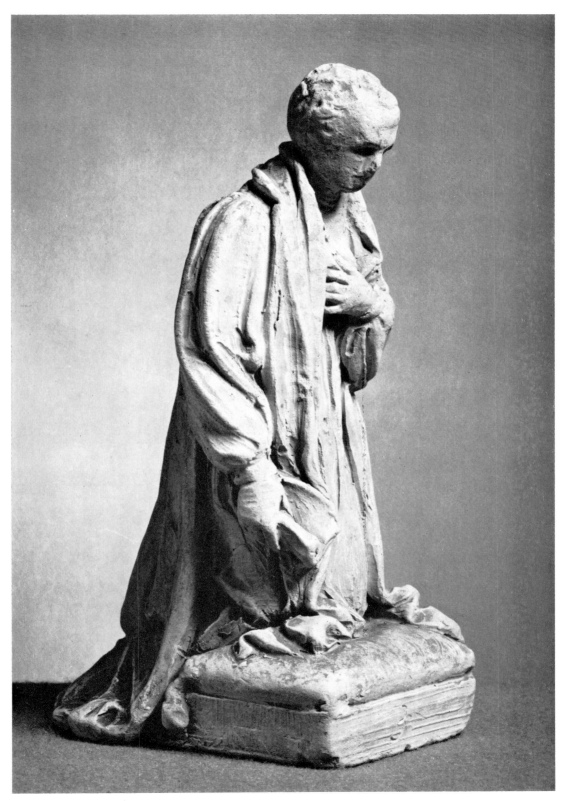

L. Alexander GOBLET b. 1764

Goblet entered the Royal Academy Schools in 1792 (under the name of Alexander), and after winning a silver medal in 1794 became an assistant to Joseph Nollekens. He appears to have remained with Nollekens as principal carver till his master's death in 1823, and it is possible that he did not long outlive him, as he ceased to exhibit at the Royal Academy in 1822. He is known to have executed the figure of Religion from Nollekens's design for the monument to Mrs Howard at Wetheral, Cumberland (see No. 37) and also, as would be expected of an assistant, to have cut busts from Nollekens's models; but he also made busts and monuments on his own account. He was clearly a competent sculptor, and he retained the affection of Nollekens, who left him all the working tools and marble in his yard.

No. 51

L. Alexander GOBLET
b. 1764

JOSEPH NOLLEKENS
(1737–1823)
1821

Bust in marble.
H. 1 ft 5¾ in. (45·1 cm.)
A.70—1965
Bequeathed by Rupert Gunnis

Inscribed on the front:
JOSEPH NOLLEKINS
Esq^r R.A. Aged 84

The subject, bare-headed and with the eyes incised, looks slightly to his right. The undraped bust is cut off square, as in a term.

Alexander Goblet was for many years principal carver in Nollekens's workshop. The bust, which gives a happier portrait of the sculptor than that suggested by his embittered biographer J. T. Smith, reveals a close knowledge of the master's style. Though unsigned, the identification is supported by a plaster version, recently on loan to the Ashmolean Museum, Oxford, which is signed and dated L. A. GOBLET, fec[it] 1821.

Goblet exhibited busts of Nollekens in the Royal Academy in 1816 and 1822,[1] but it is not possible to say which was the one listed in the Sale of Nollekens's collection after his death.[2]

[1] A. Graves, *The Royal Academy of Arts*, vol. III, 1905, p. 252, nos. 945 and 1041.
[2] Christie's, 4 July 1823, Lot 112.

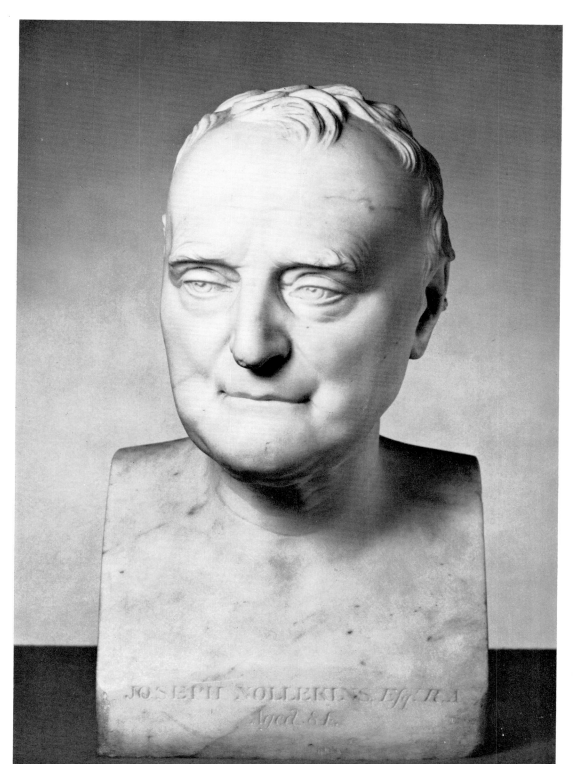

JOSEPH NOLLEKINS Esq RA
Aged 81.

Samuel JOSEPH 1791–1850

Joseph was a pupil of the sculptor-modeller, Peter Rouw, but entered the Royal Academy Schools in 1811. He won two silver medals in his first years there, and a gold medal in 1815. From 1823 to 1828 he worked in Edinburgh, becoming a foundation-member of the Royal Scottish Academy in 1826. The rest of his life was spent in London. He was a sculptor of some talent, who moved away from the dominating fashion for classicism, and produced works of considerable naturalism, his masterpiece being the seated figure of William Wilberforce (1838) for Westminster Abbey. His ability did not, however, bring him success; he became a bankrupt in 1848 and died poor. His work consisted chiefly of busts, but he made a few statues and a small number of monuments.

No. 52

Samuel JOSEPH
1791–1850

GEORGE IV (1762–1830.
Succeeded 1820)
1831

Bust in marble.
H. (including base)
2 ft 10½ in. (87·6 cm.)
A.12–1956
Signed and dated on the
back: S. JOSEPH.
SCULPT 1831

The King, with his hair floridly curled, looks to his half-right, his head tilted slightly upwards. His dress is classical and consists of a tunic with a band of ornament along the top, and a cloak caught on his left shoulder by a clasp in the form of a lion's mask.

The bust, which is posthumous, gives an idealized representation of the subject, similar to the famous portrait by Sir Thomas Lawrence. The sculptor had special ability to endow a posthumous portrait with vitality, as may be seen in his statue of William Wilberforce (1838) in Westminster Abbey.

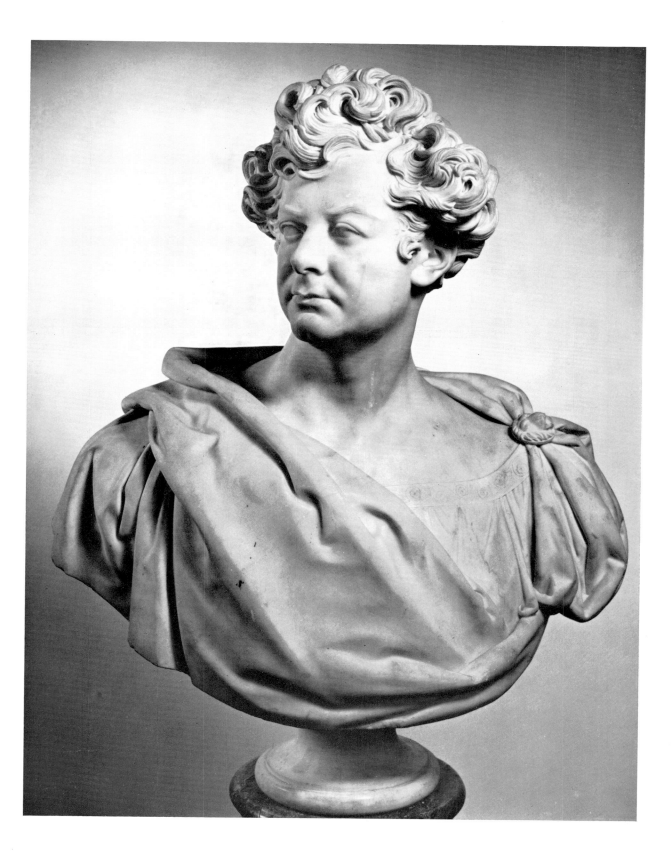